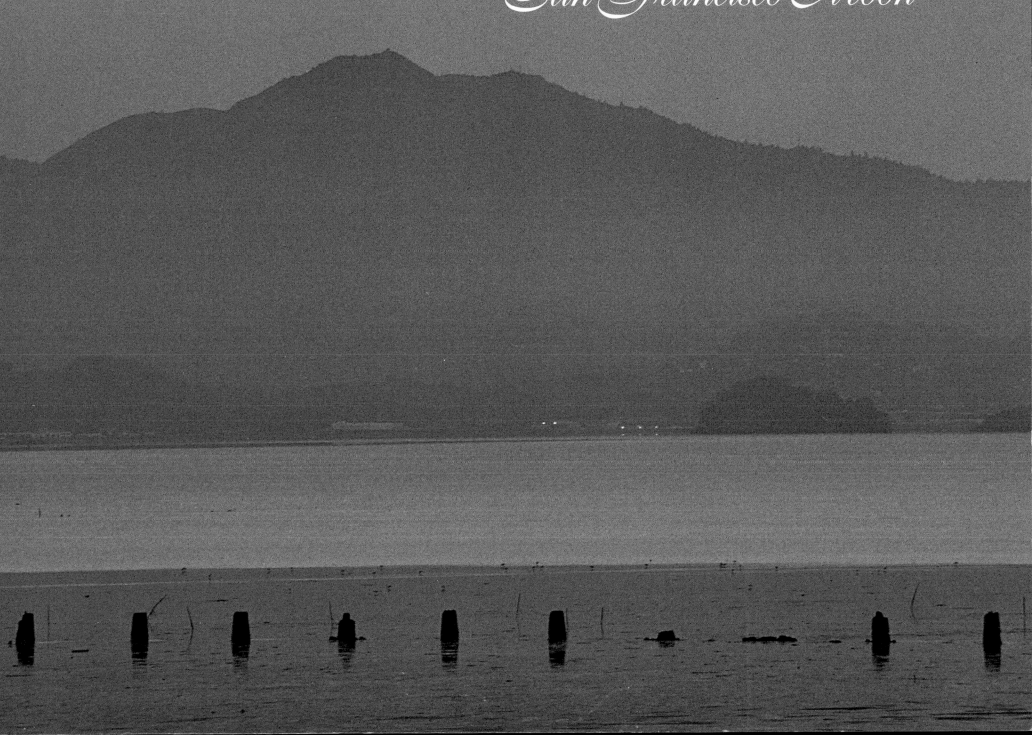

San Francisco Moon

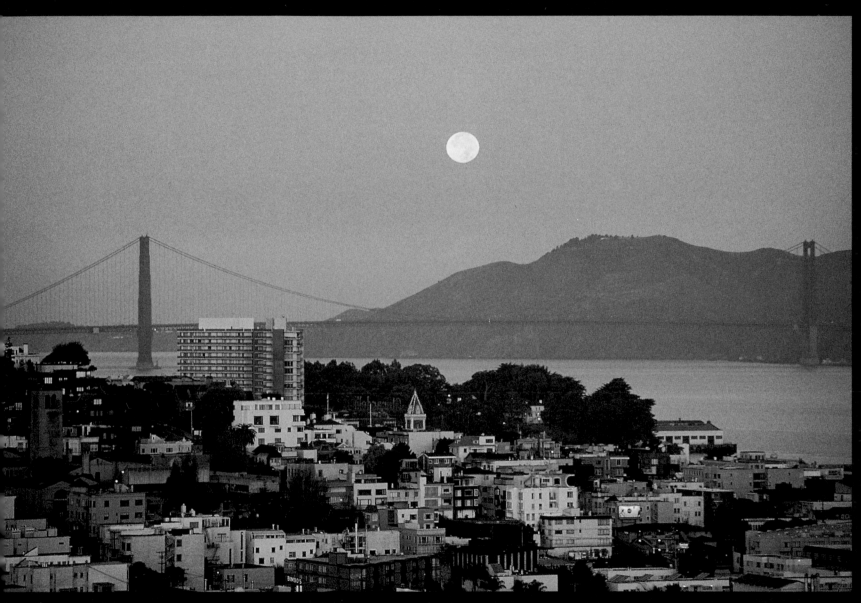

○ *Cover:* June moonrise from Marin headlands; *Previous page:*
July moonset, Mt. Tamalpais; *Above:* November moonset from
Russian Hill; *Opposite:* March moonset, Hyde Street Pier

San Francisco Moon

A COLLECTION OF PHOTOGRAPHY

by James Rigler

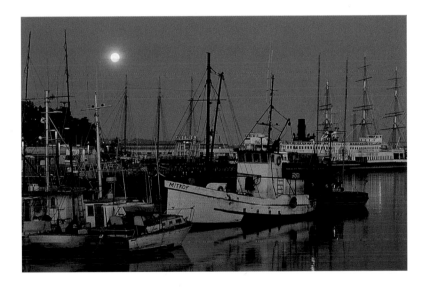

CELESTIALARTS
Berkeley, California

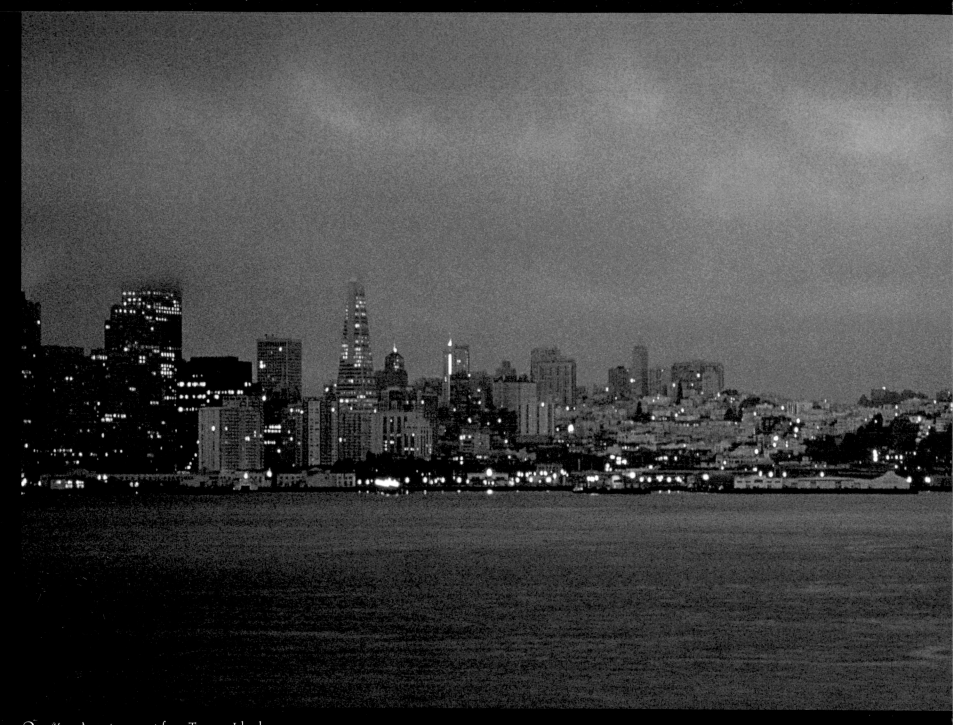

○ *Above:* August moonset from Treasure Island

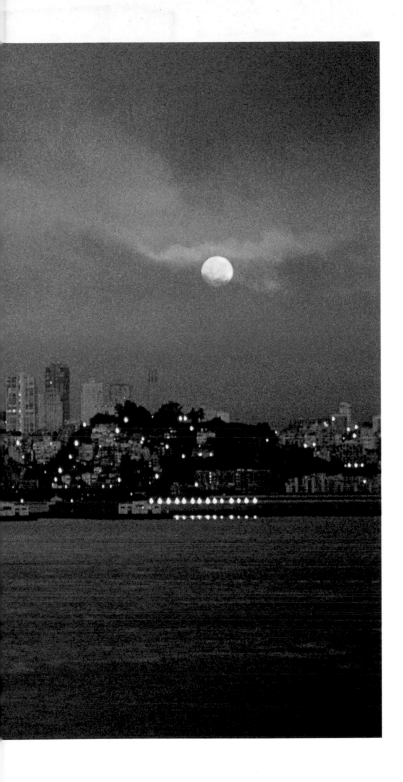

Dedication

This book is a celebration
of the unique romance and spirit of
San Francisco.

I dedicate it to all my fellow moon chasers
who love The City.
You know who you are . . .

Chasing the Moon

San Francisco is a photographer's paradise. There is no place more beautiful or romantic than The City by The Bay—a place that is cherished by locals and visitors alike.

For the past seven years, I have paid homage to The City from a unique perspective. Three days out of every month, I've loaded my camera gear into the truck and set out to photograph the moon as it rises and sets. It's meant many late nights and early mornings, during which I have witnessed some truly beautiful sights—things I wouldn't have believed if I hadn't seen them with my own eyes. With a little luck and a lot of persistence, I've been able to capture these magical moments on film as they unfolded quietly over San Francisco.

I'm amazed by how aligned with the moon I've become, consciously aware of its presence and location, even during the middle of the day when it is only a faint white fingernail in a sea of blue sky. What began as a fascination has become an enduring passion,

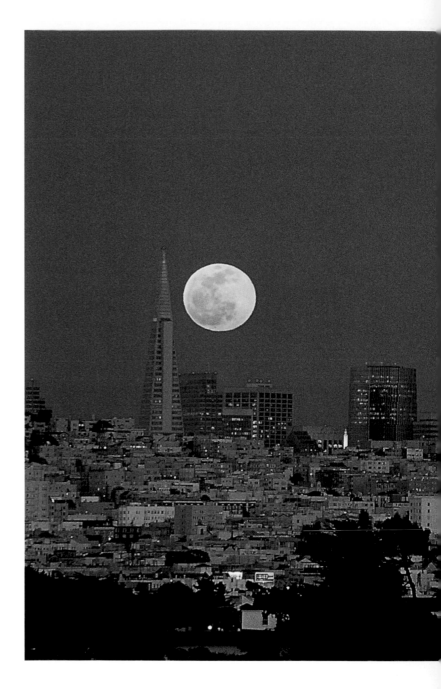

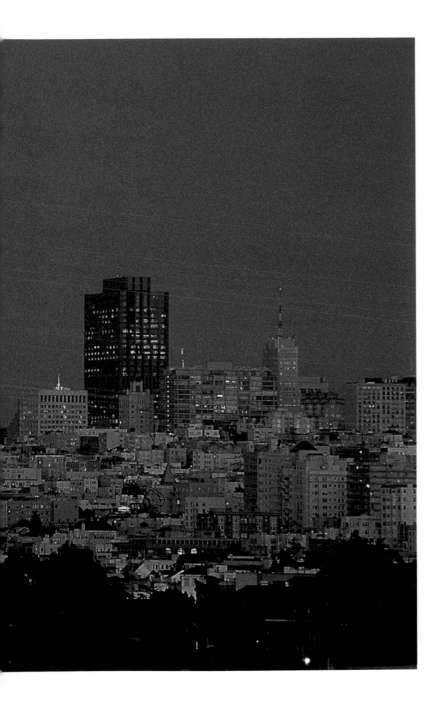

something I look forward to every month, wondering just where the moon will rise and what color it will be this time when it breaks free of the horizon.

Several days later, I'm surrounded by yellow Kodak boxes of slides just back from the lab. It's like having a birthday every month of the year, opening boxes with great excitement and peering through the slide viewer to see a different side of San Francisco in the moonlight—another facet of the jewel.

Chasing the full moon over the hills and bridges of San Francisco has created a wonderful rhythm in my world, allowing me to move a bit more gracefully to the beat of The City and the feeling it inspires in my heart and soul.

This book of moons is my way of sharing that feeling with those kindred spirits who have been touched by the romance and beauty of San Francisco.

May your moons be full.

○ April moonrise from above
Crissy Field

Capturing Color and Light

One thing that has become clear to me through my years of observation is that Mother Nature needs no assistance in the color department. With that in mind, none of these images have been computer enhanced or distorted by the use of filters— only the filters of my mind, which many would say is distortion enough. What you see is what actually took place while I was on watch.

Photography is a meditation that has helped me learn the art of patience. I am now able to wait for the magical moments of life to reveal themselves in their own time frames, instead of frantically racing around trying to make things happen according to my schedule. I am more consciously aware of the world around me and am better able to anticipate where and when the fireworks will occur. I've become comfortable knowing just when to squeeze the trigger on the cable release, capturing the beauty of the moment forever on film.

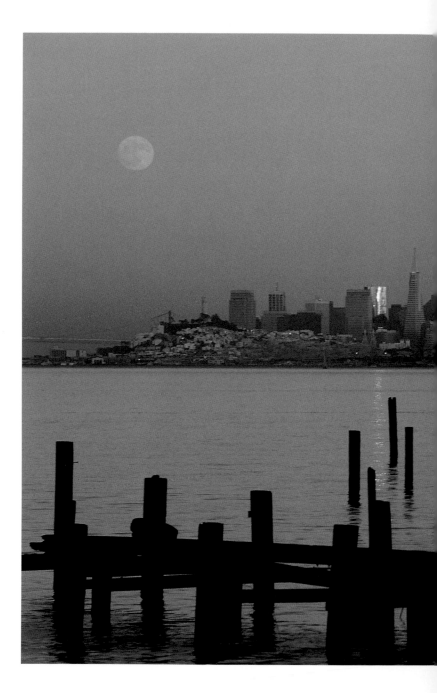

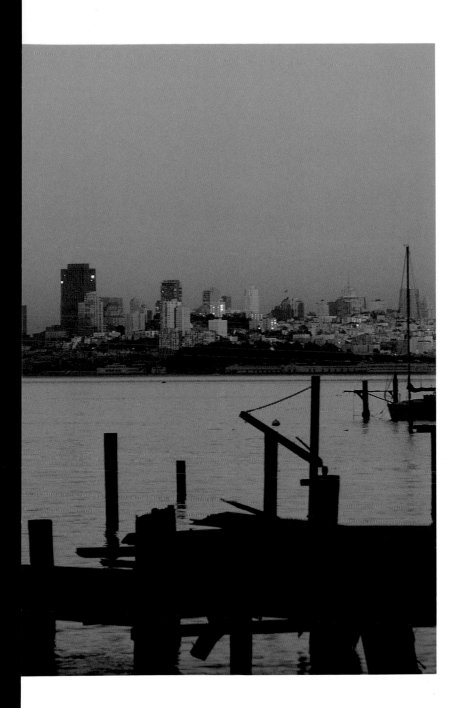

After choosing the images for this book, I sat down with my old friend Paul Chutkow, a gifted writer. Over a good bottle of wine and some celebratory cigars, Chutkow picked my brain about the effect the full moon has had on my life for the last six years. The resulting conversation, recounted in the last few pages of this book, includes anecdotes about several of the images that greatly affected me, as well as details about the equipment I use and the techniques I've learned while fumbling around, both literally and metaphorically, in the darkness. J.R.

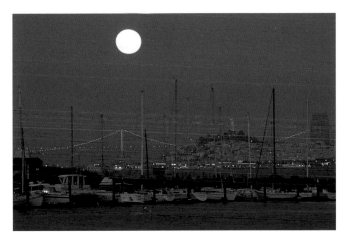

○ *Left:* July moonrise from the old Valhalla; *Above:* May moonrise from Coast Guard Station

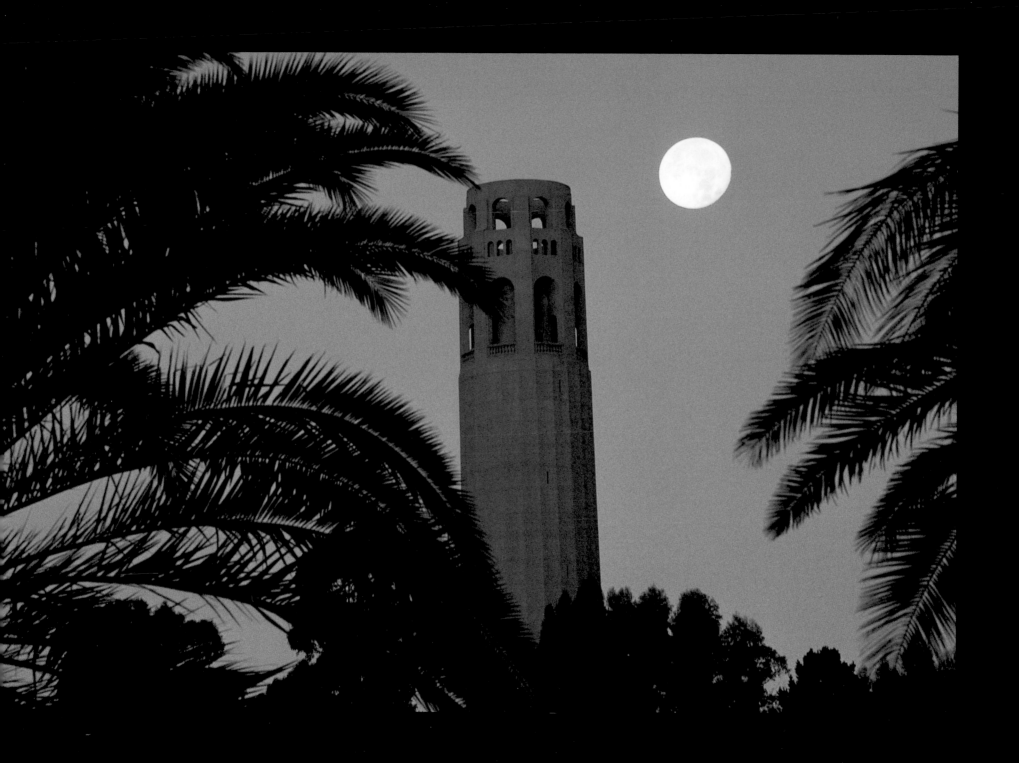

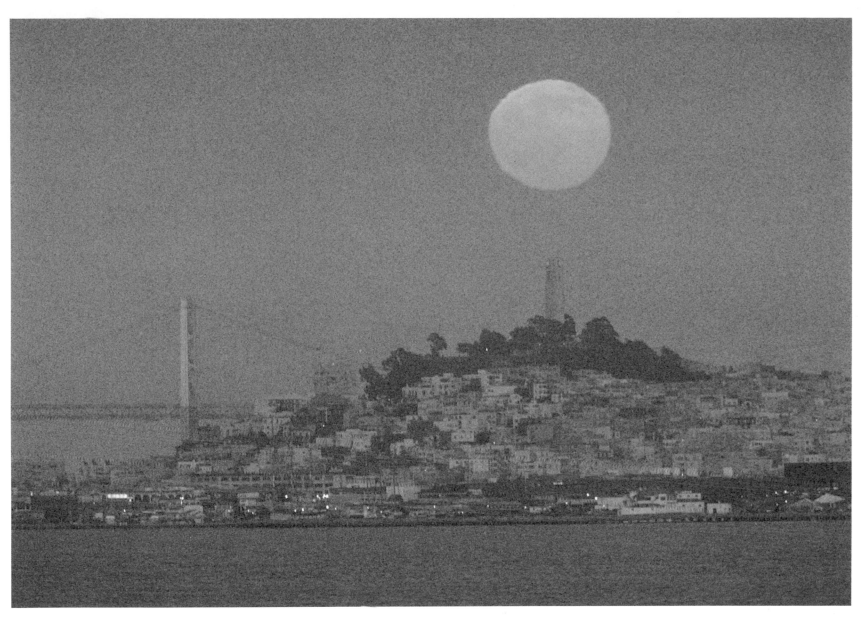

○ *Opposite:* November moonset, Coit
Tower; *Above:* June moonrise from under
the north tower of the Golden Gate Bridge

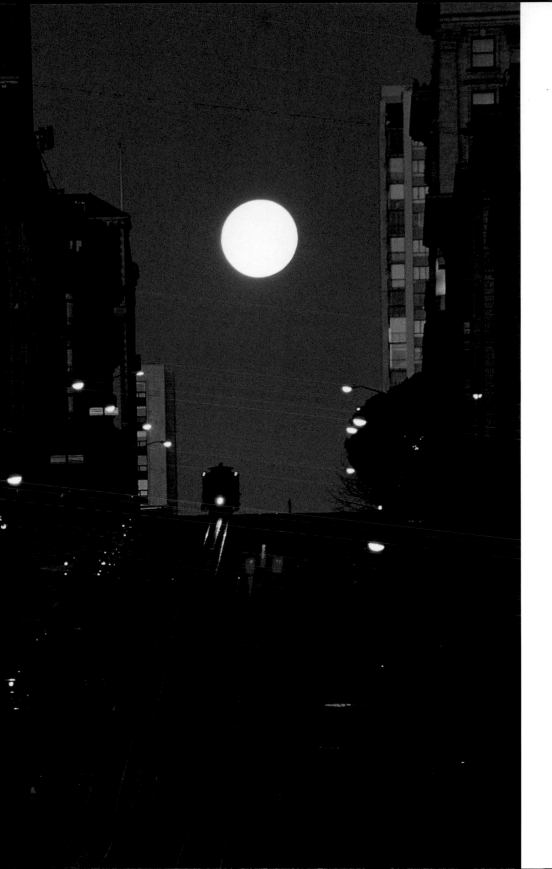

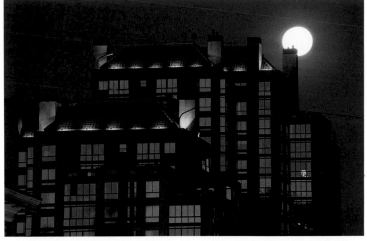

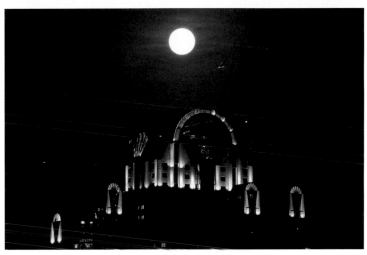

○ *Opposite:* March moonset, Lombard Street;
Center: March moonset, top of California
Street; *Above:* April moonsets from Sutter
Street (top) and Marriott Hotel

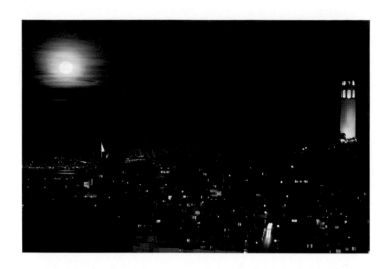

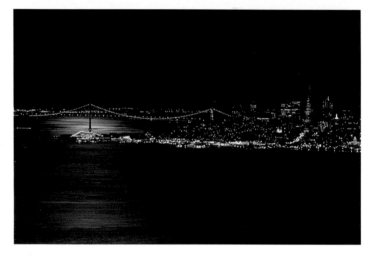

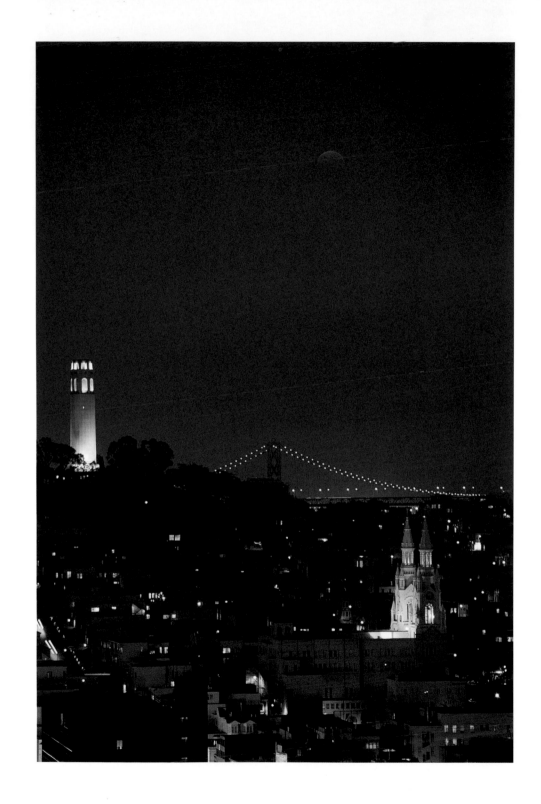

○ *Above:* January moonrise over the East Bay (top); May moonbeam under Bay Bridge; *Center left:* September moonrise, total lunar eclipse; *Center right:* November moonset, Ferry Building; *Far right:* October moonrise, Ft. Point Wharf (top); August moonset near Ft. Mason, sculpture of Congressman Phillip Burton

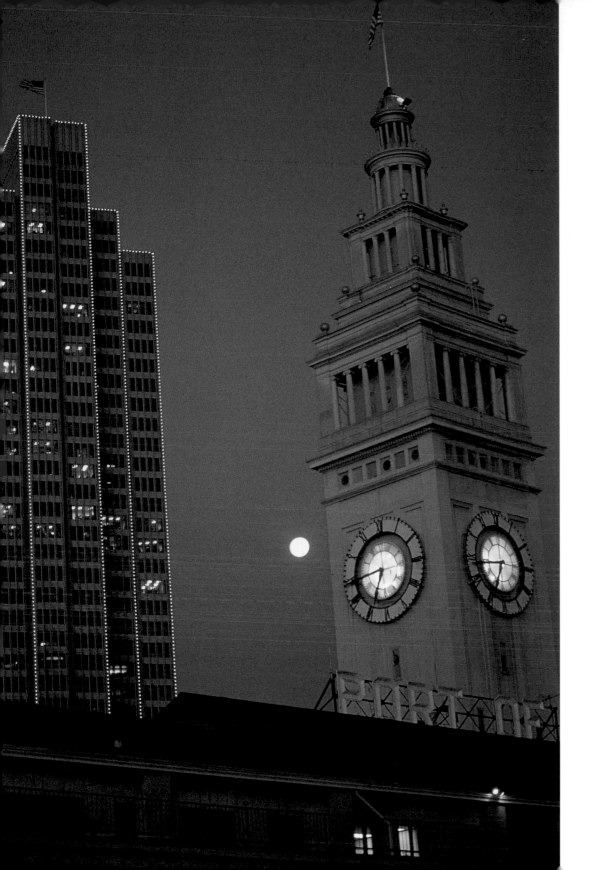
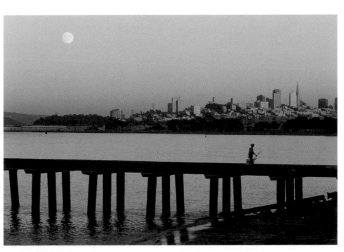
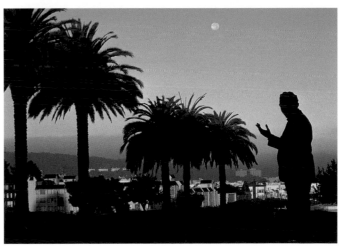

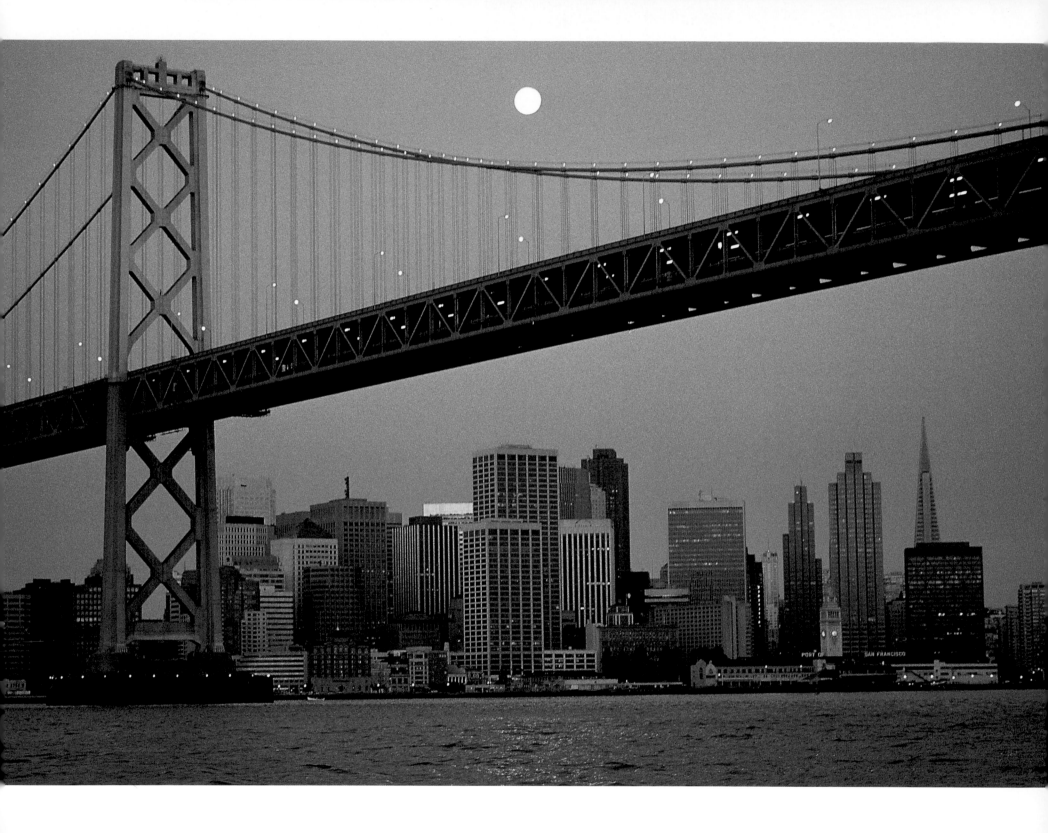

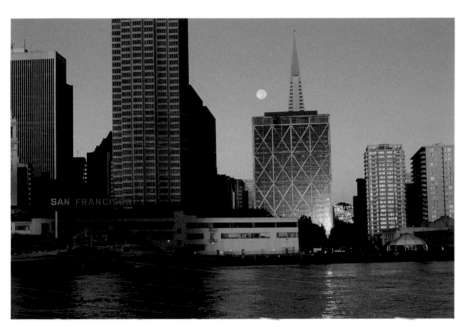

❍ August moonsets from Frank's
boat in the bay as the sun rises

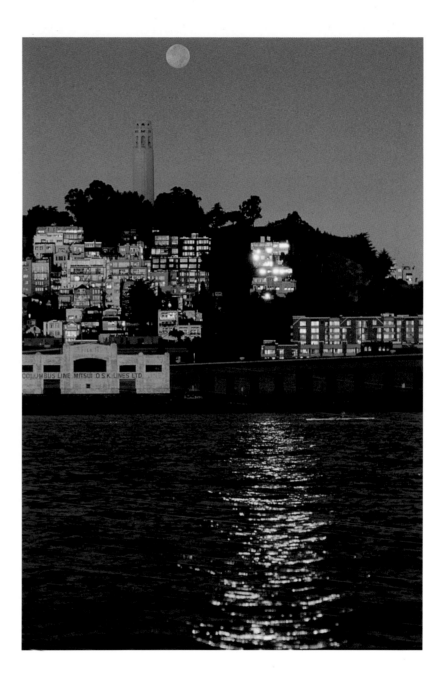

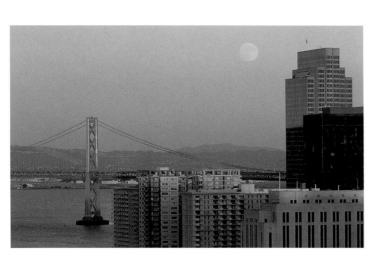

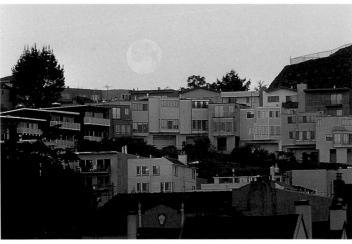

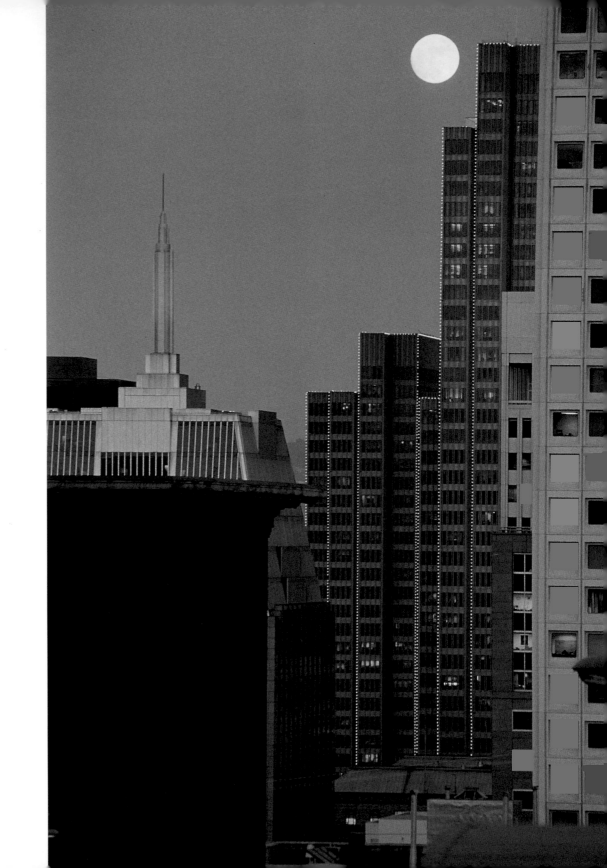

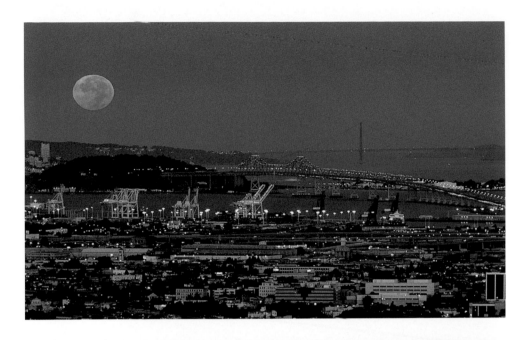

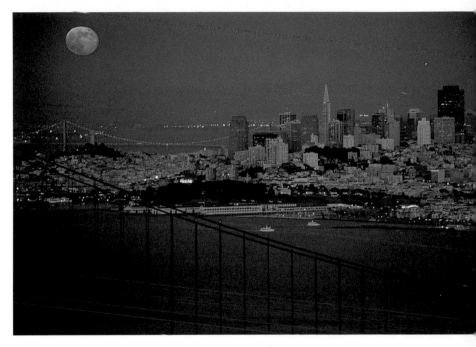

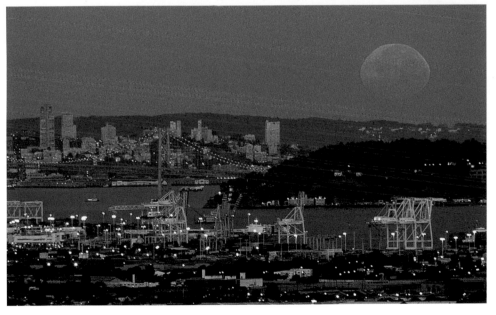

○ *Opposite*: September moonrise over Bay Bridge (top); April moonset in Sunset district; *Center left*: December moonrise over Embarcadero; *Center right*: September moonsets from Sky-line Boulevard; *Above*: July moonrise from the Marin headlands

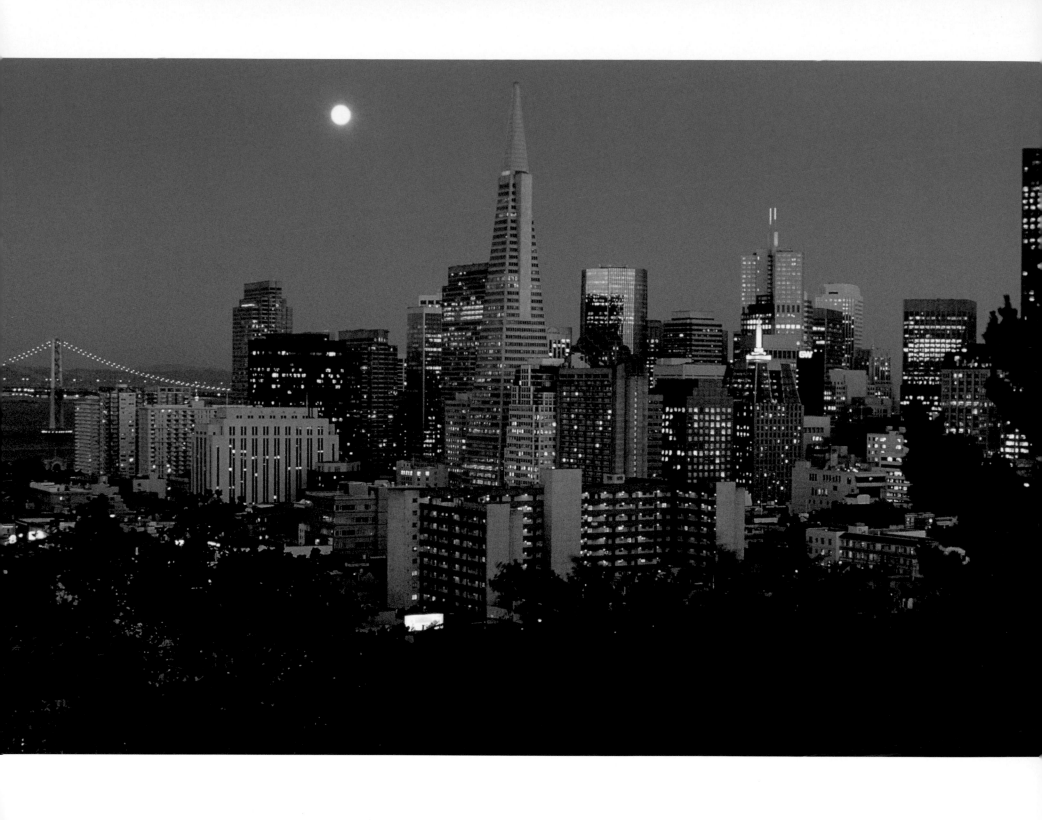

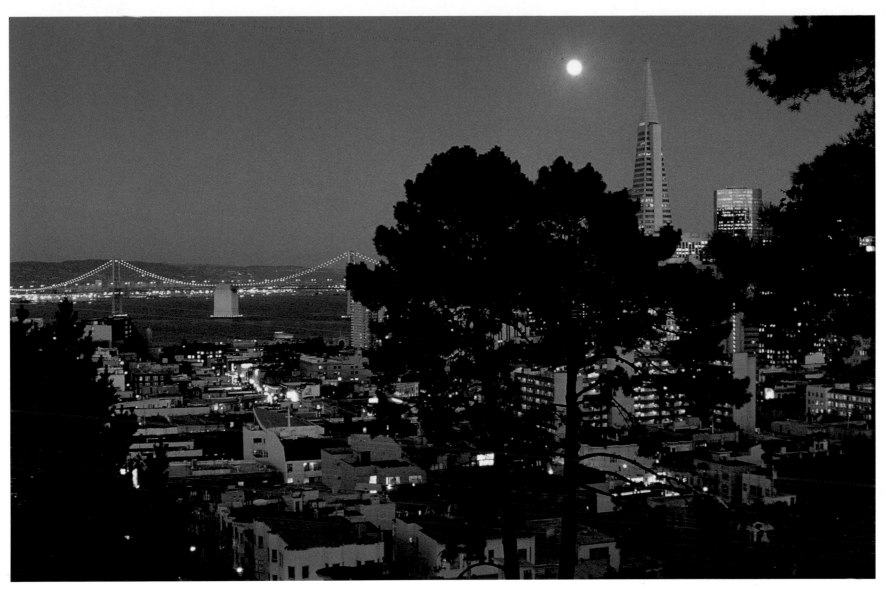

❍ September moonrises from
Coolbrith Park

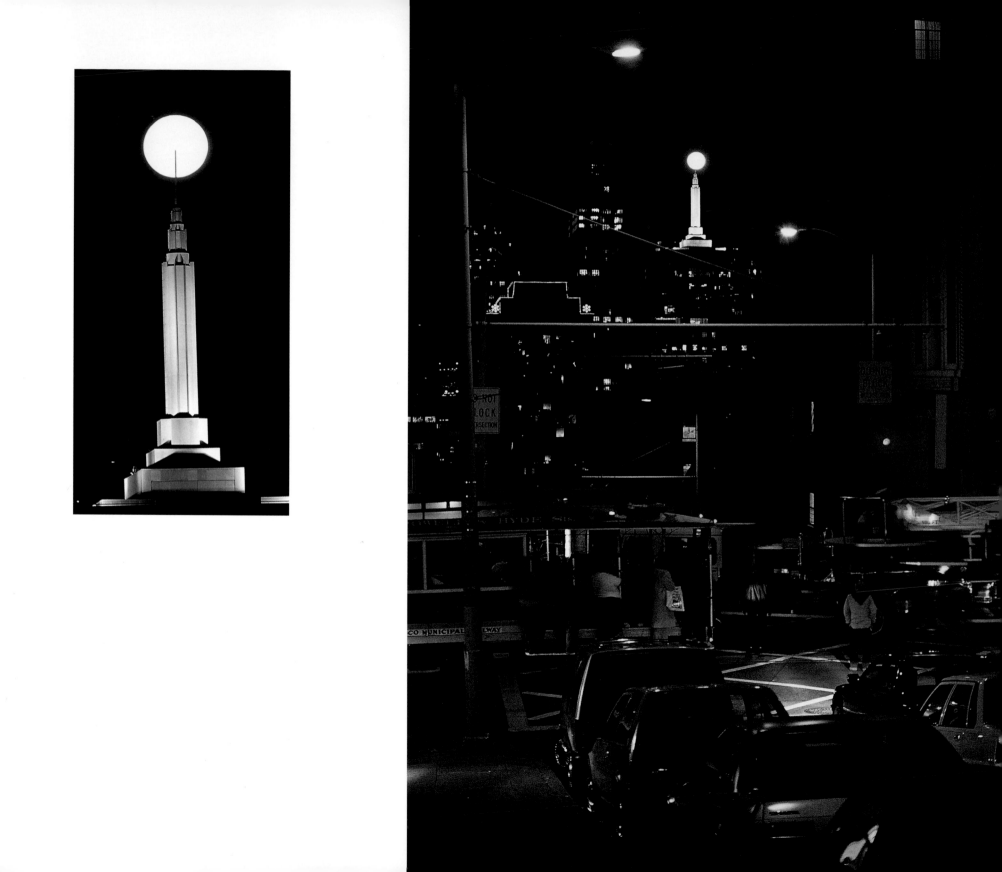

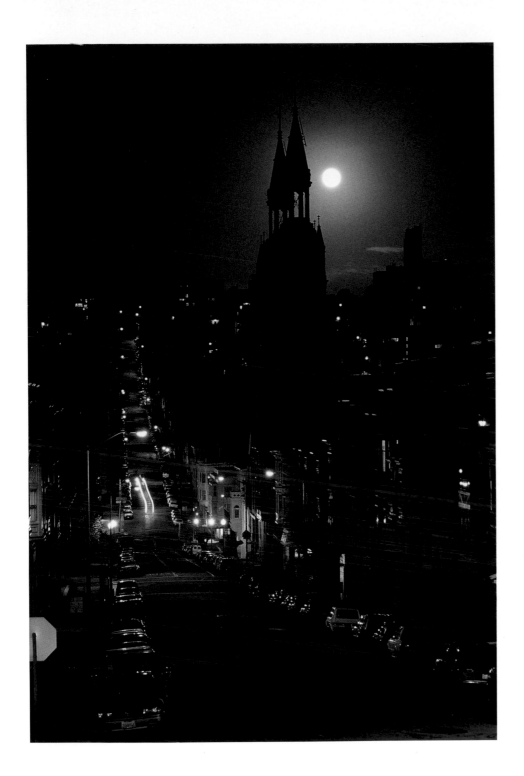

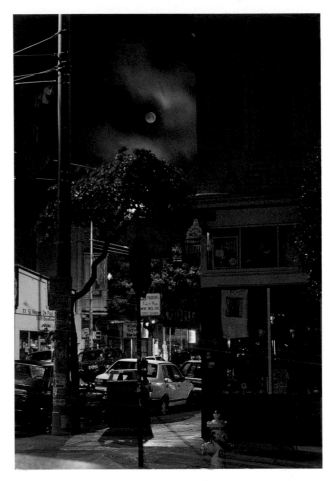

○ *Opposite:* February moonrise, 505 Montgomery; *Center left:* February moonrise, Powell & Clay Streets; *Center right:* March moonset, Saints Peter & Paul Church; *Above:* May moonset, Haight & Ashbury Streets

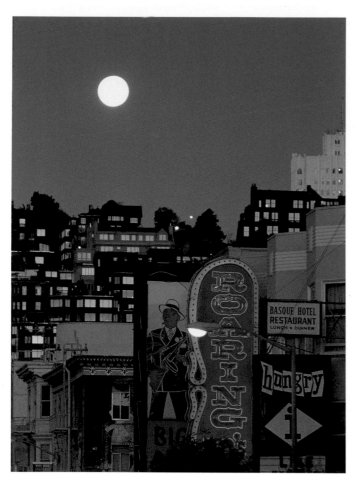
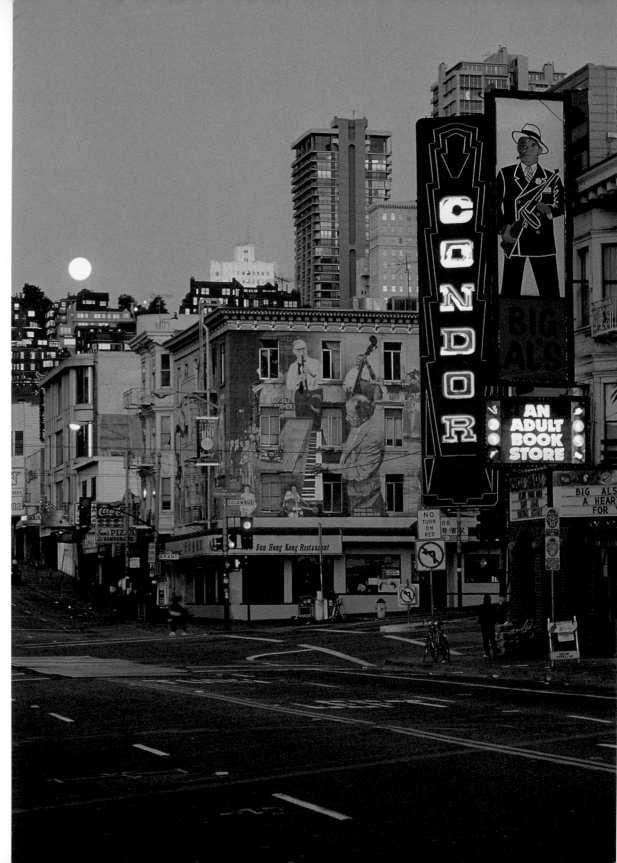

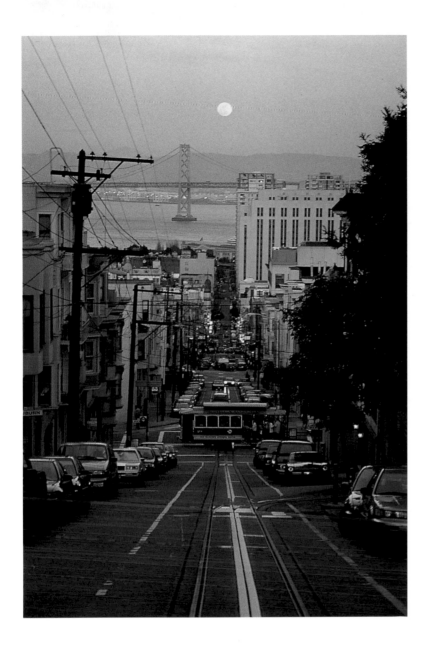

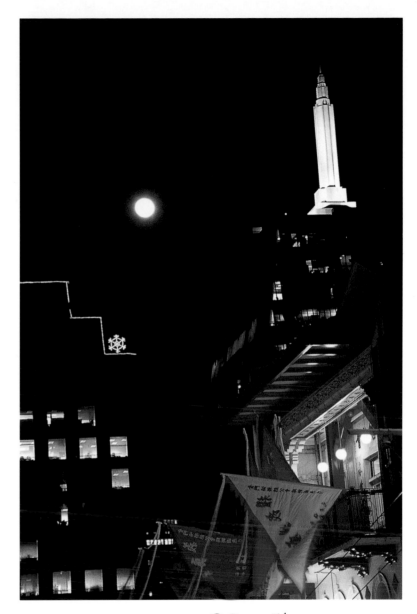

○ *Opposite:* February moonsets,
Broadway & Columbus Streets; *Left:*
February moonrise, Jackson Street;
Above: February moonrise, Chinatown

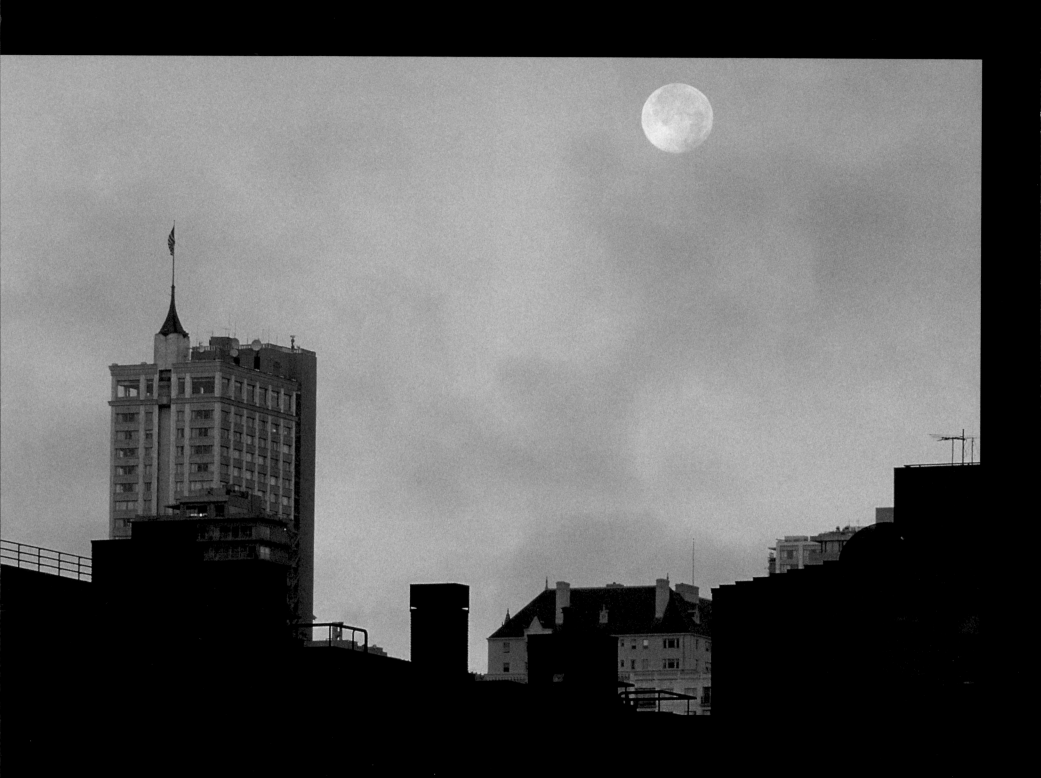

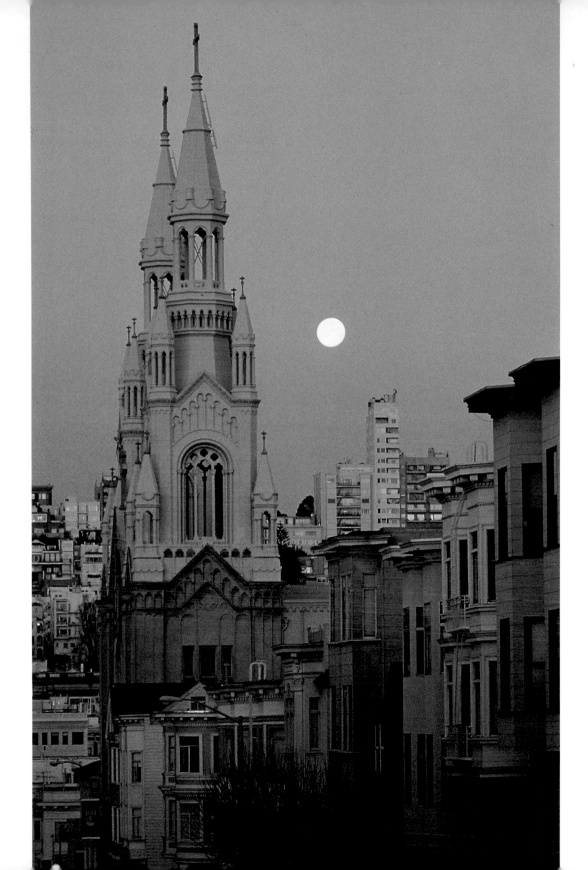

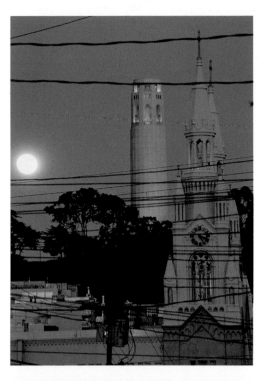

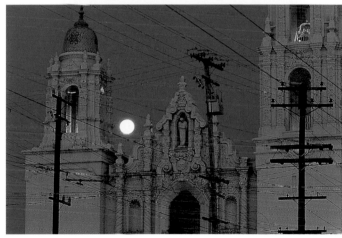

◯ *Opposite:* June moonset from Herb Caen Way; *Left:* February moonset, North Beach; *Above:* January moonrise, North Beach (top); April moonset, Mission Dolores

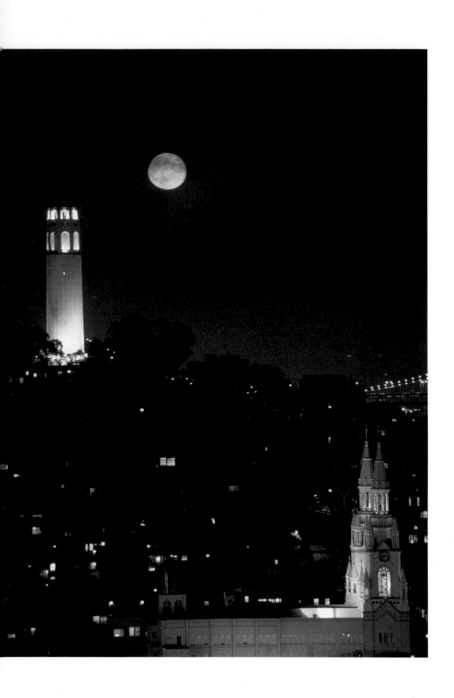
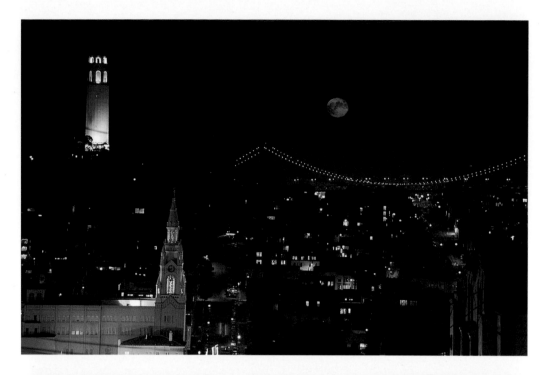
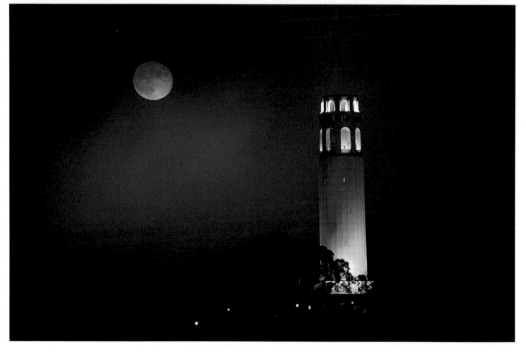

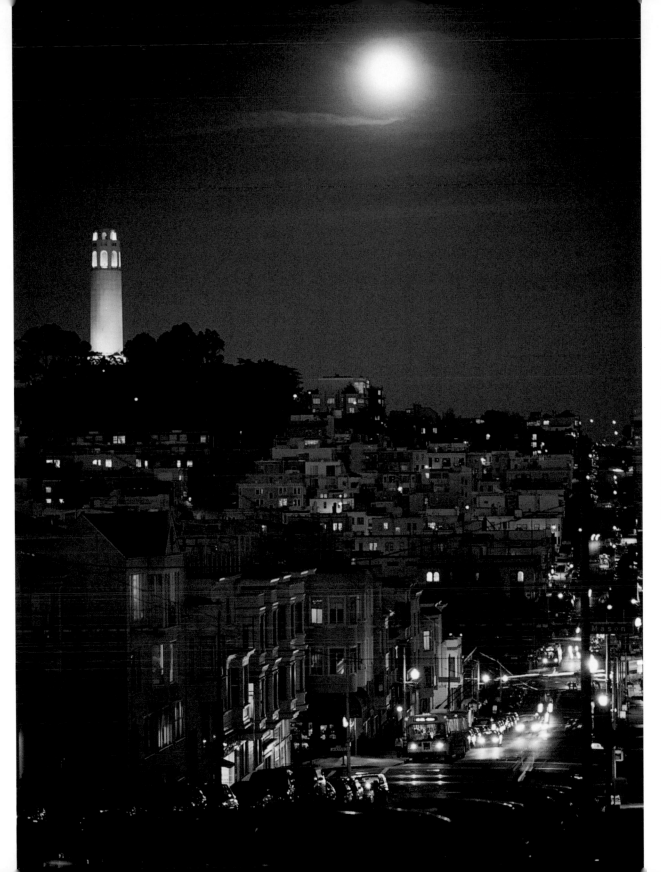

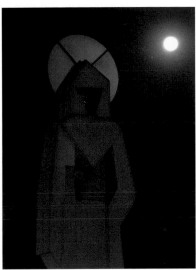

○ *Opposite:* September moonrises, Coit Tower; *Left:* January moonrise, Union Street; *Above:* October moonset behind the patron saint of San Francisco at Candlestick Park

O December moonsets near
Ghirardelli Square

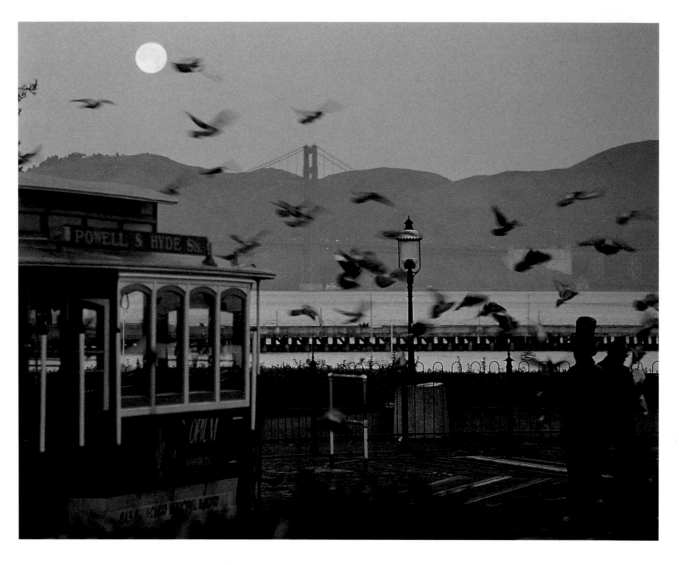

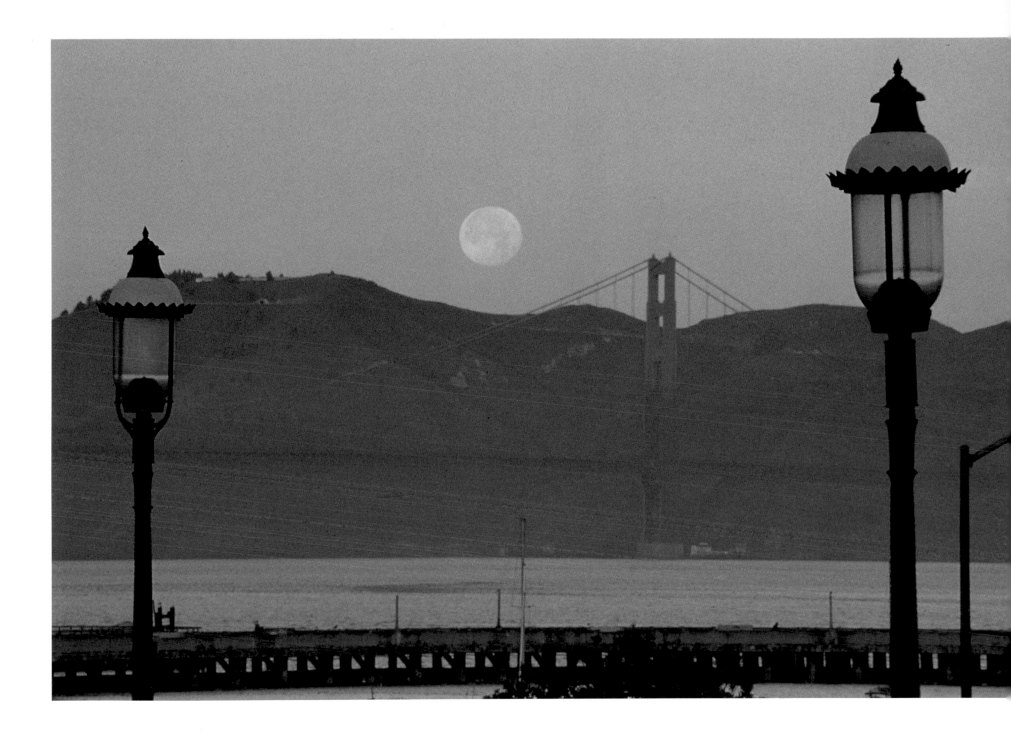

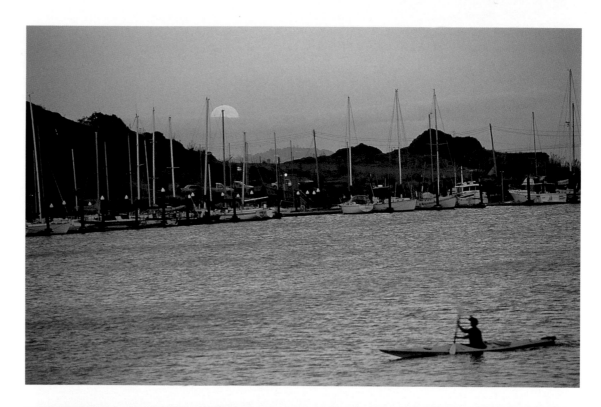

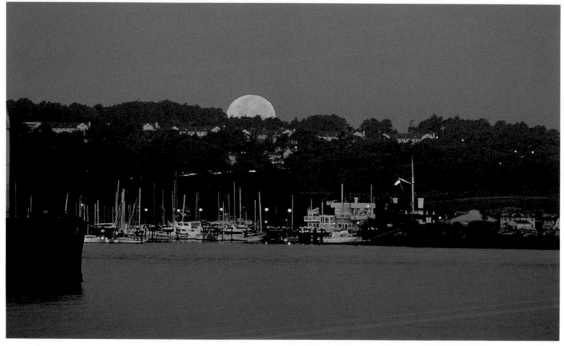

○ *Right:* August moonrise, Horse-shoe Bay near Ft. Baker (top); August moonset from Municipal Pier; *Opposite:* August moonrise above San Francisco fog; *Opposite far right:* July moonrise, Sausalito sailboat

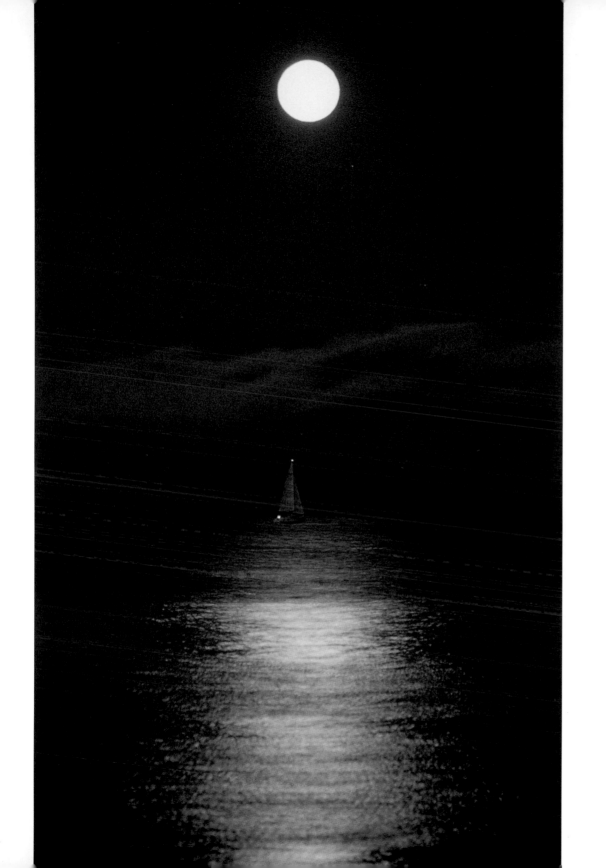
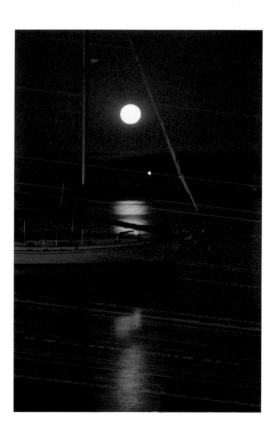

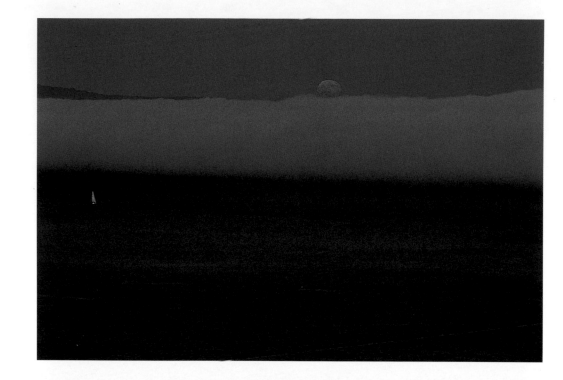

◯ August moonrises over
San Francisco fog

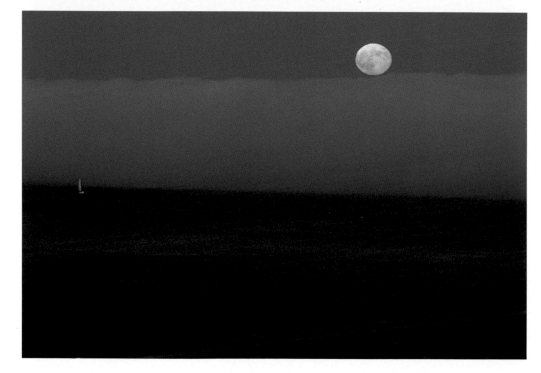

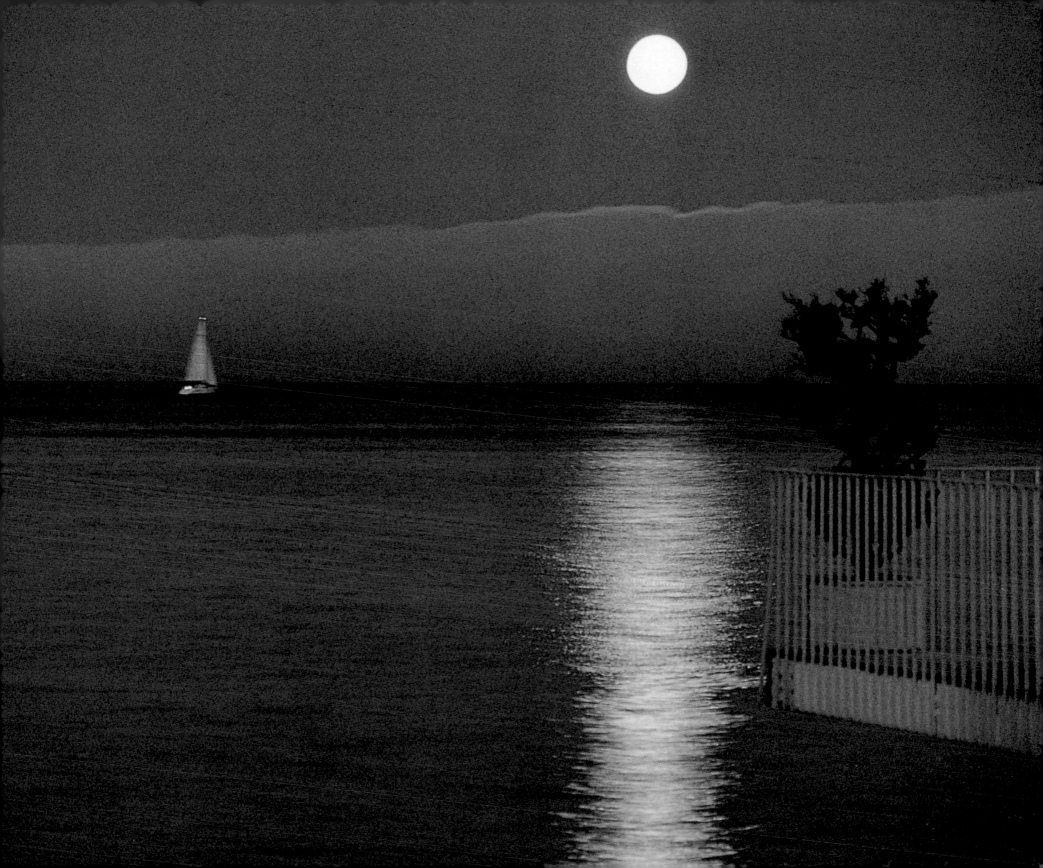

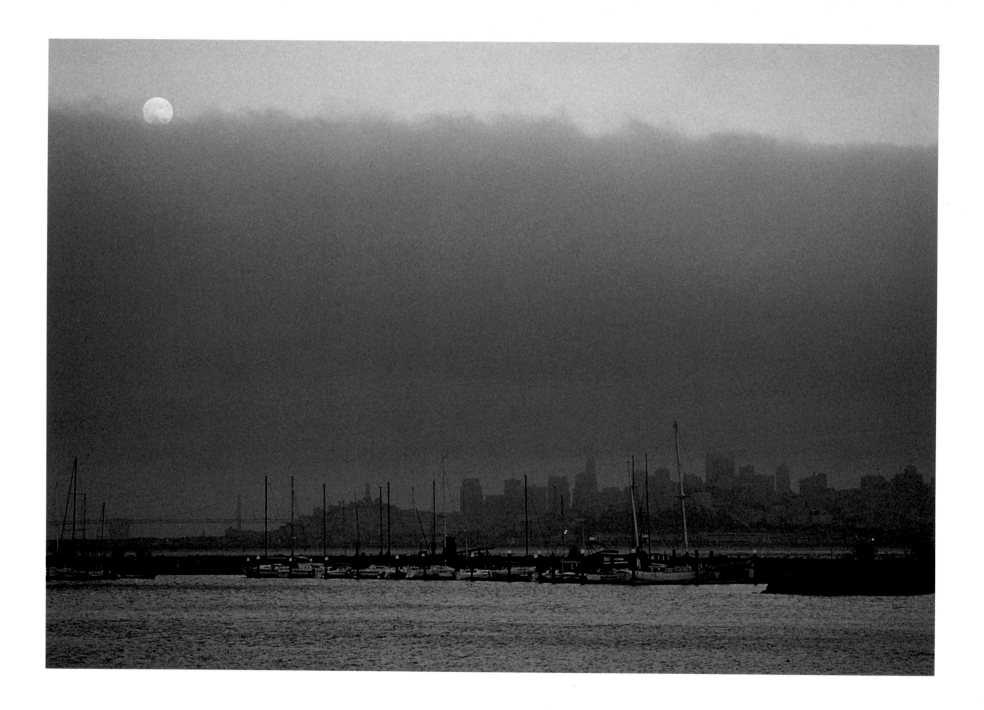

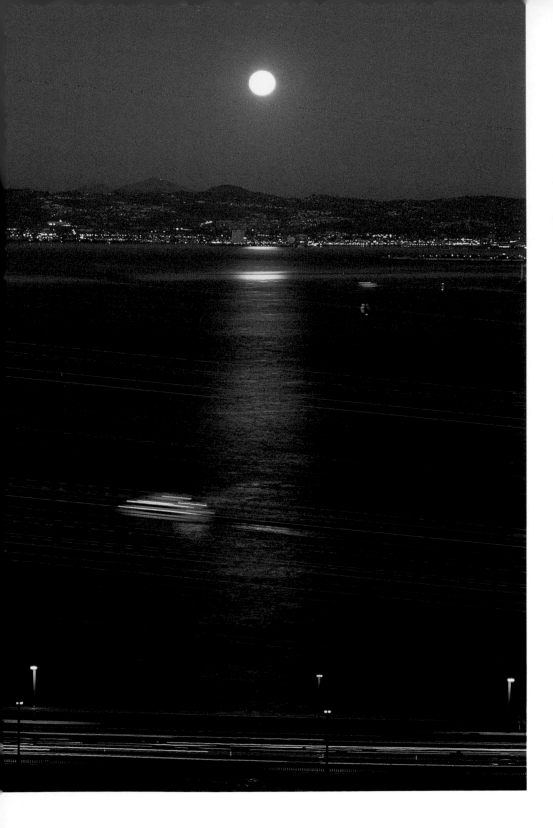

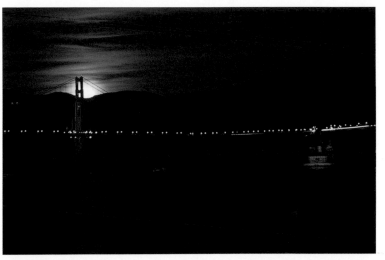

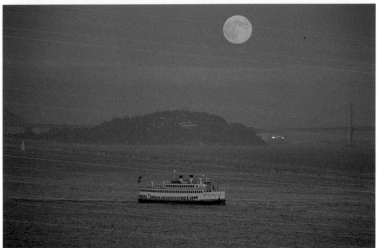

○ *Opposite:* August moonrise from Coast Guard Station near Ft. Baker; *Left:* October moonrise, Marin headlands; *Above:* December moonset, Golden Gate Bridge (top); August moonrise over Angel Island

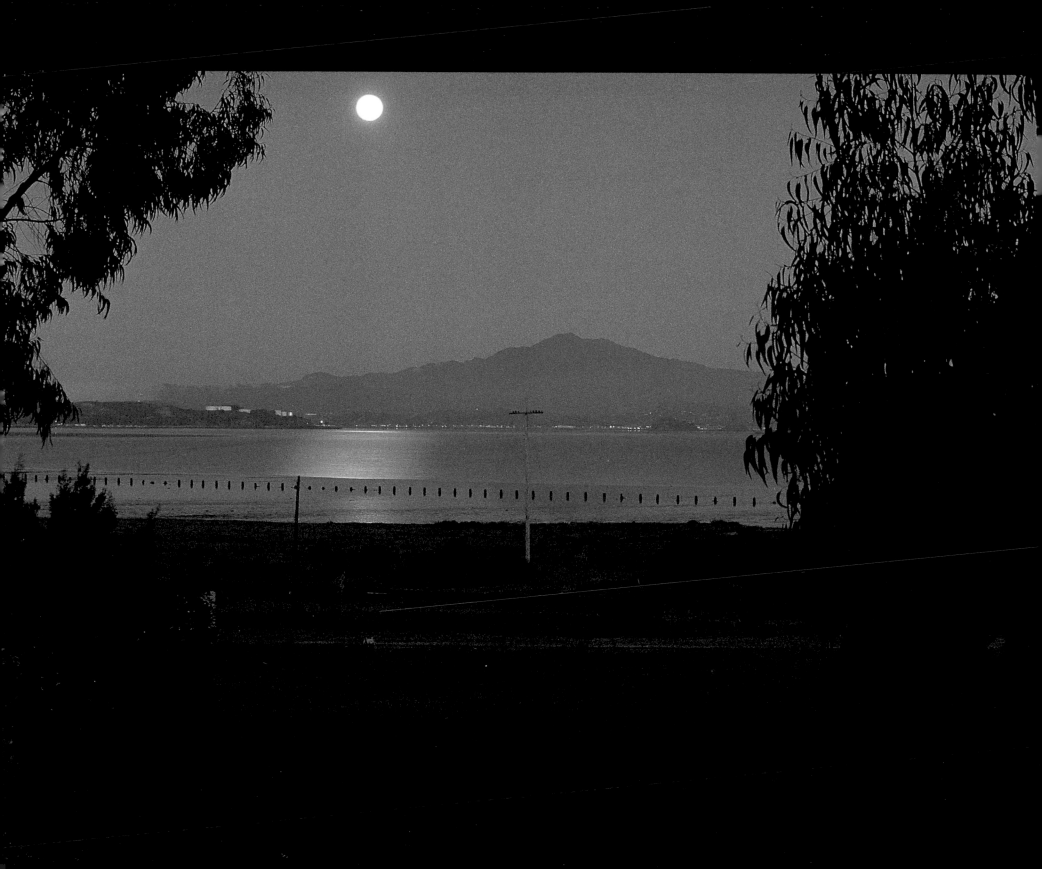

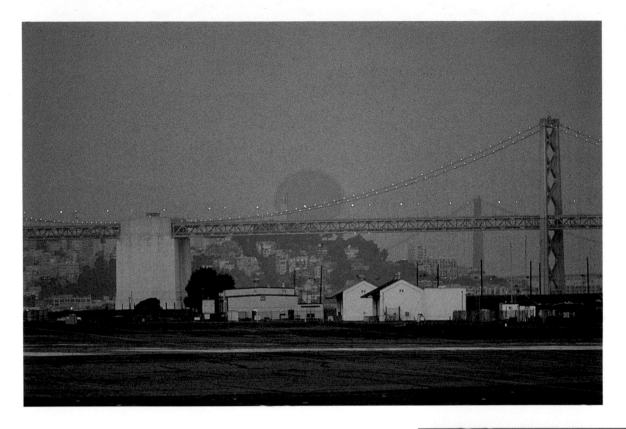

○ *Opposite:* July moonset, Mt. Tamalpais from Pt. Pinole; *Clockwise:* February moonset from Alameda Naval Station; same moonset a few minutes earlier; and May moonrise from Pt. Cavallo

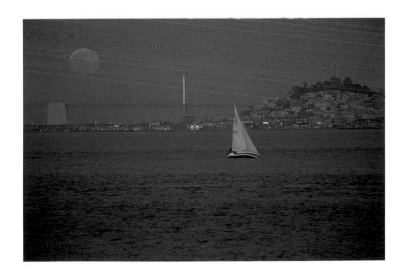

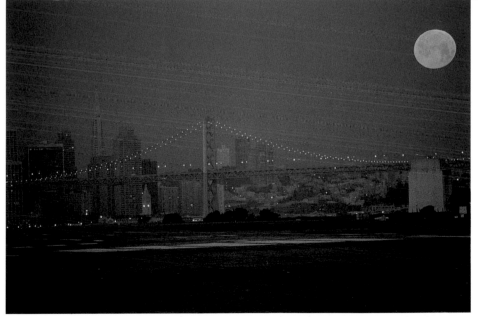

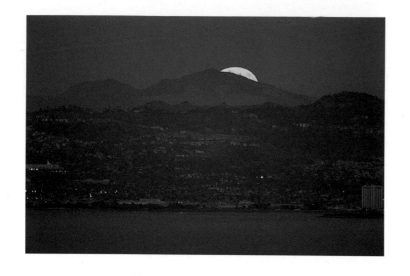
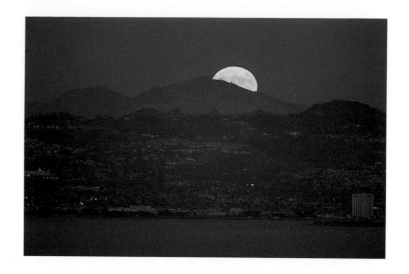
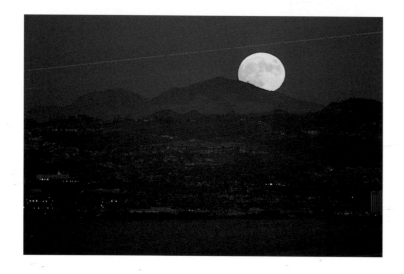
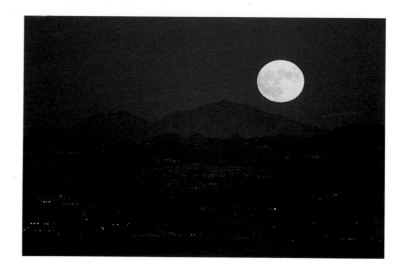

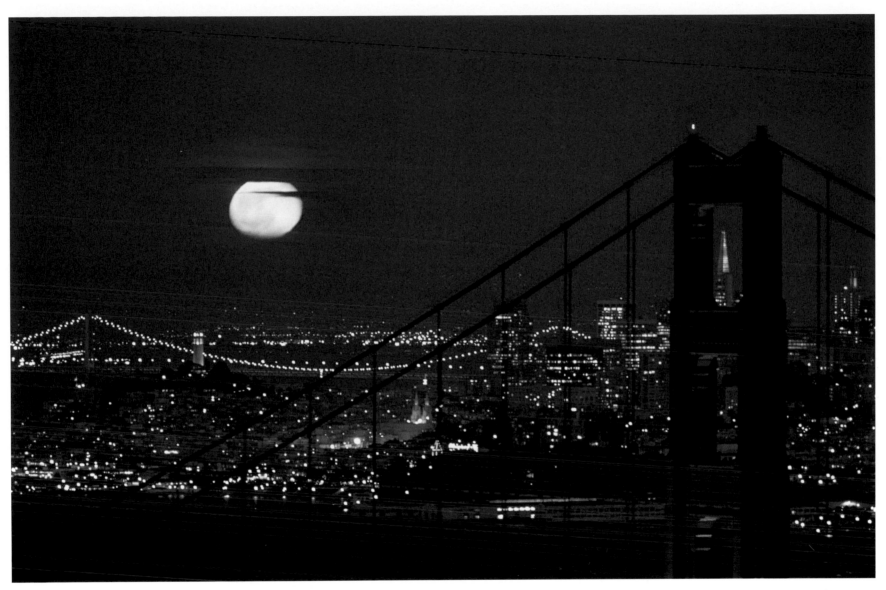

◯ *Opposite:* October moonrise sequence, Mt. Diablo; *Above:* April moonrise from the Marin headlands

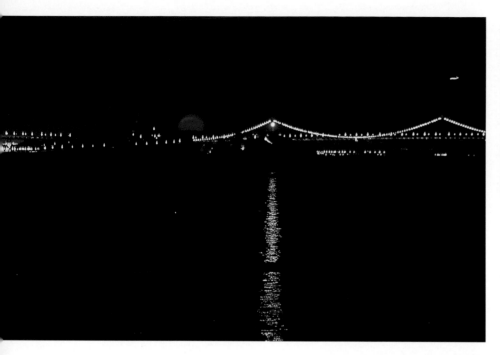

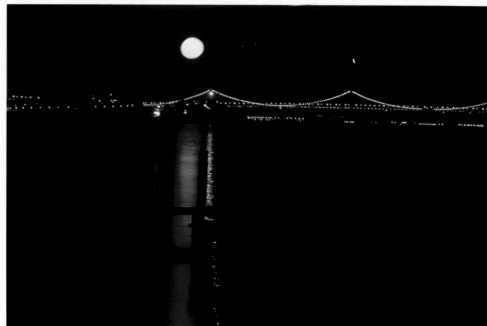

○ *Clockwise:* May moonrise over Alcatraz Island; the same moonrise a few minutes later; and May moonrise with Bay Bridge & Coit Tower; *Opposite:* December moonrise under the Bay Bridge

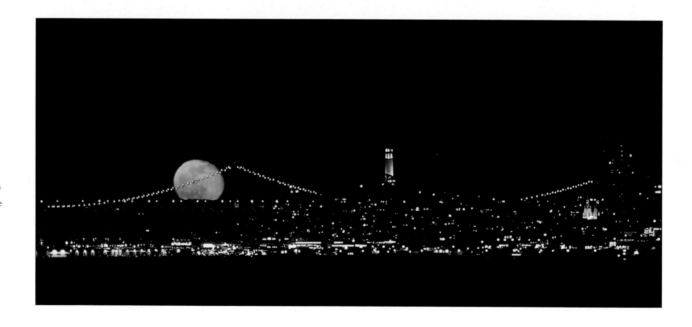

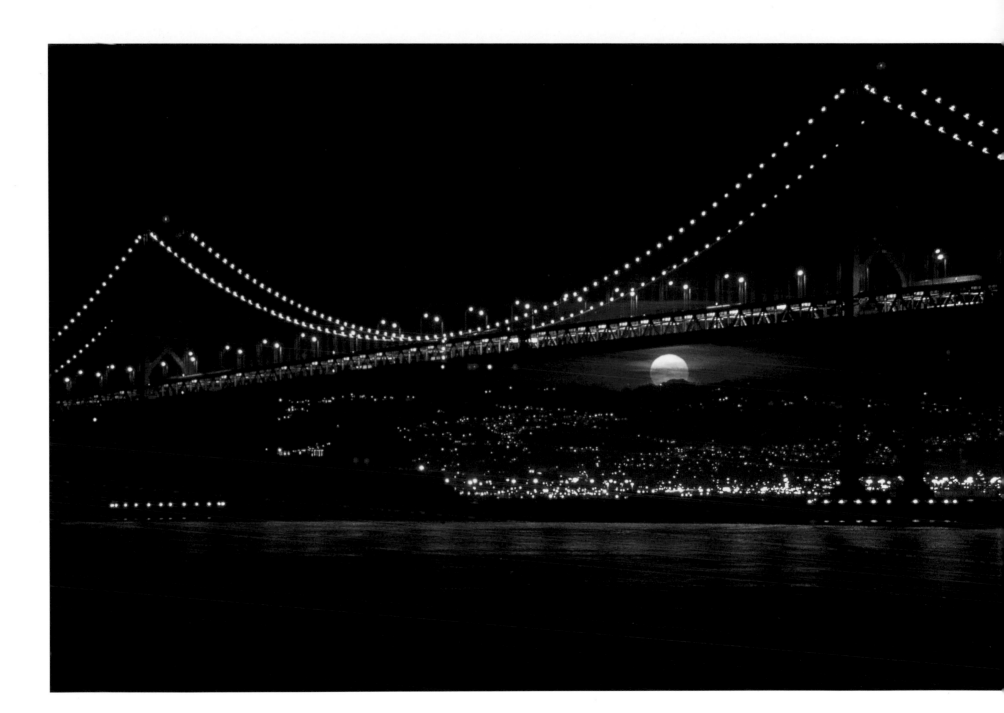

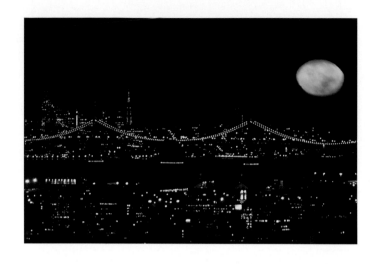
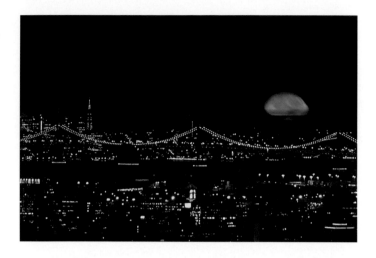
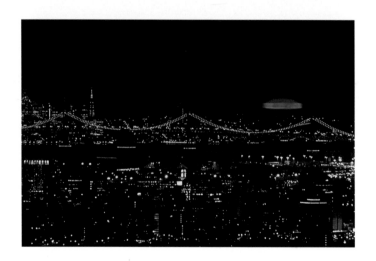
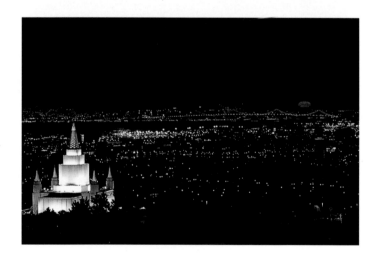

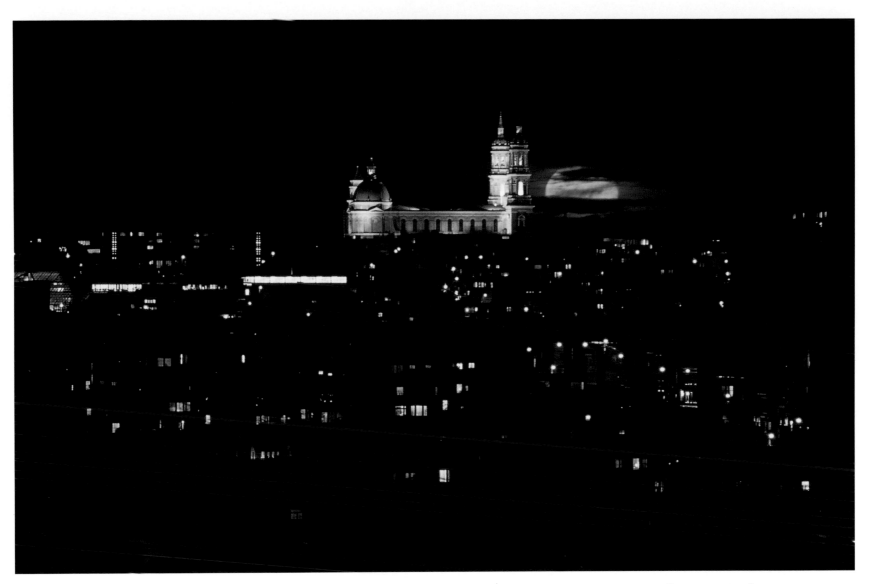

O *Opposite:* October moonset sequence from the Oakland hills; *Above:* March moonrise, St. Ignatius Church

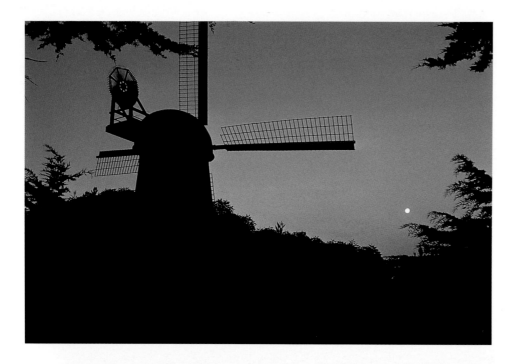

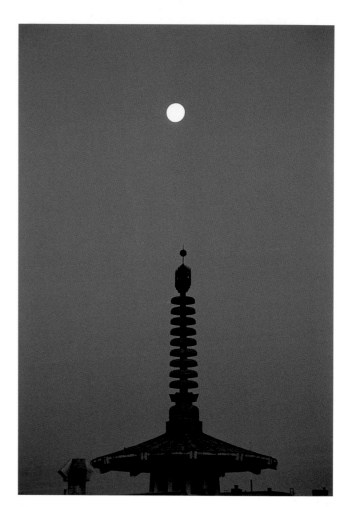

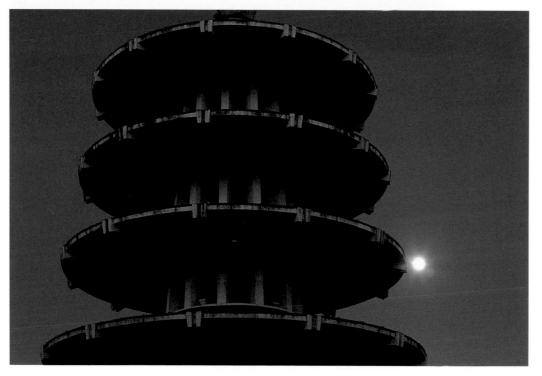

◯ *Clockwise from top:* March moonset behind windmill at Golden Gate Park/Ocean Beach; April moonsets with the pagoda in Japan Center; *Opposite:* March moonset, Palace of Fine Arts

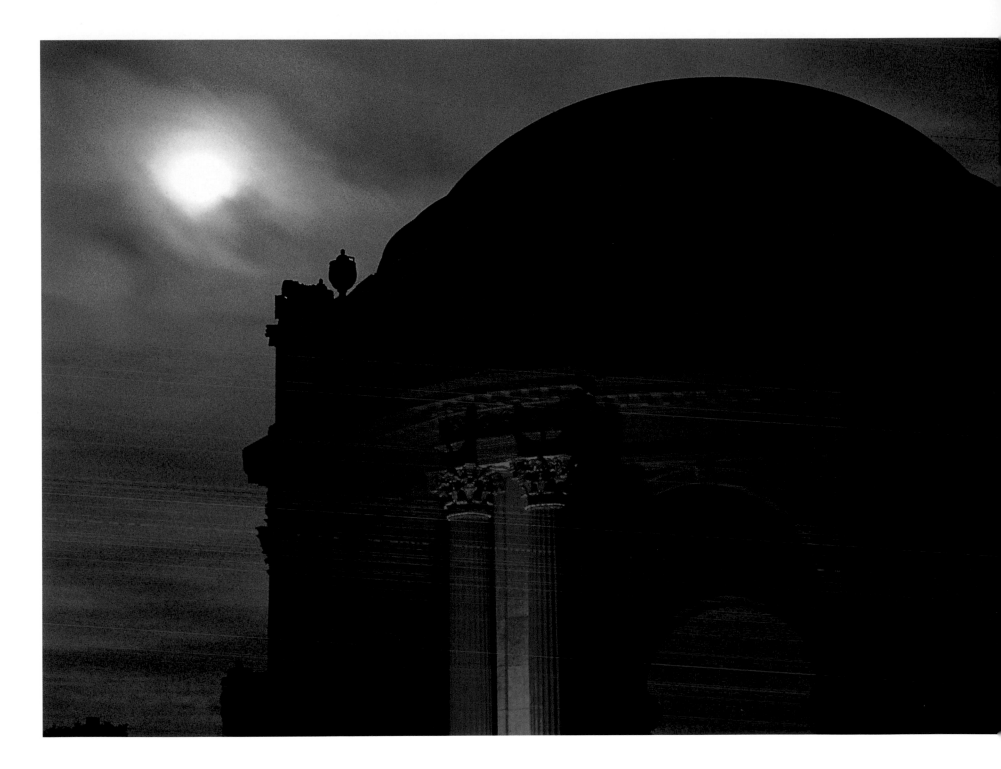

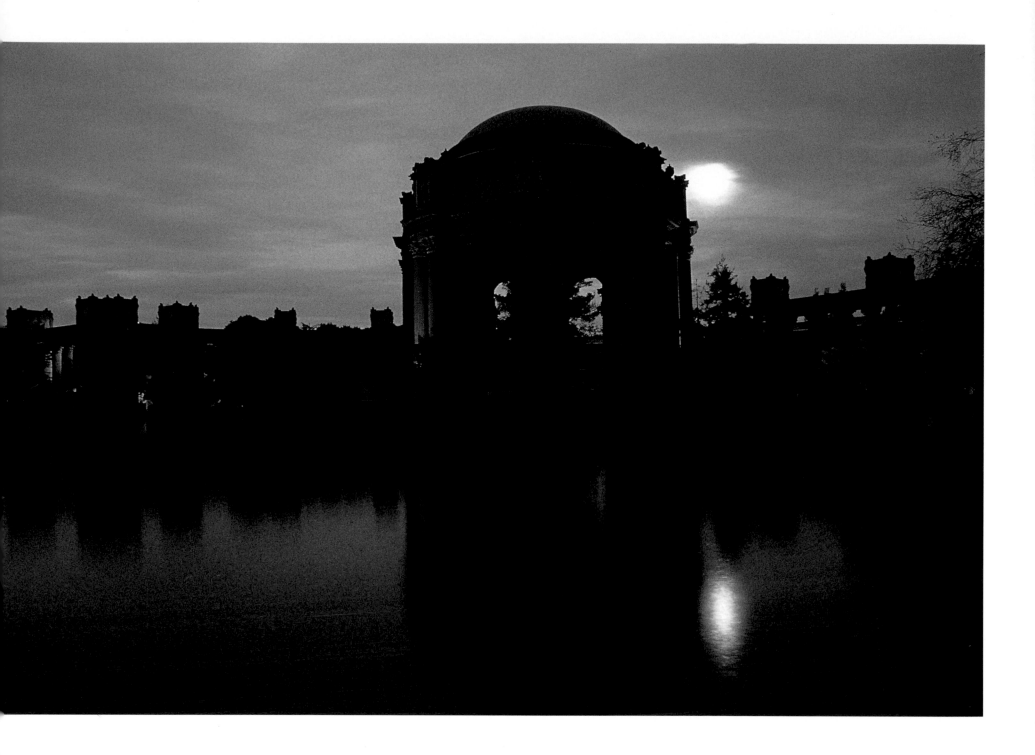

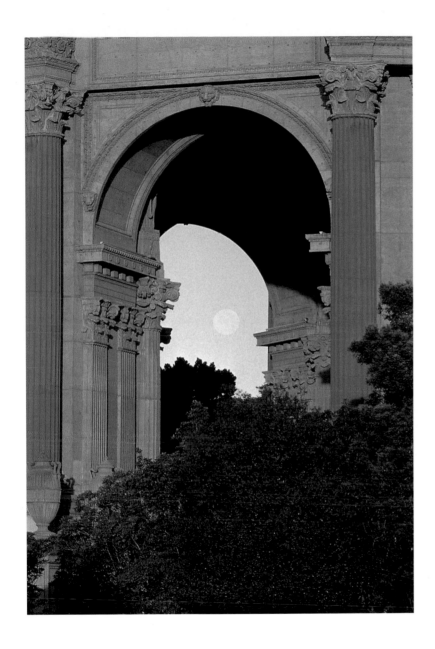

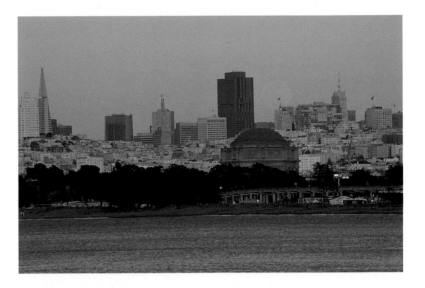

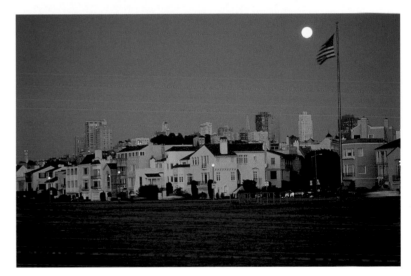

◯ *Opposite:* March moonset, Palace of
Fine Arts; *Left:* June moonset, Palace
of Fine Arts; *Above:* May moonrise
from Ft. Point Wharf (top); May
moonrise from the Marina Green

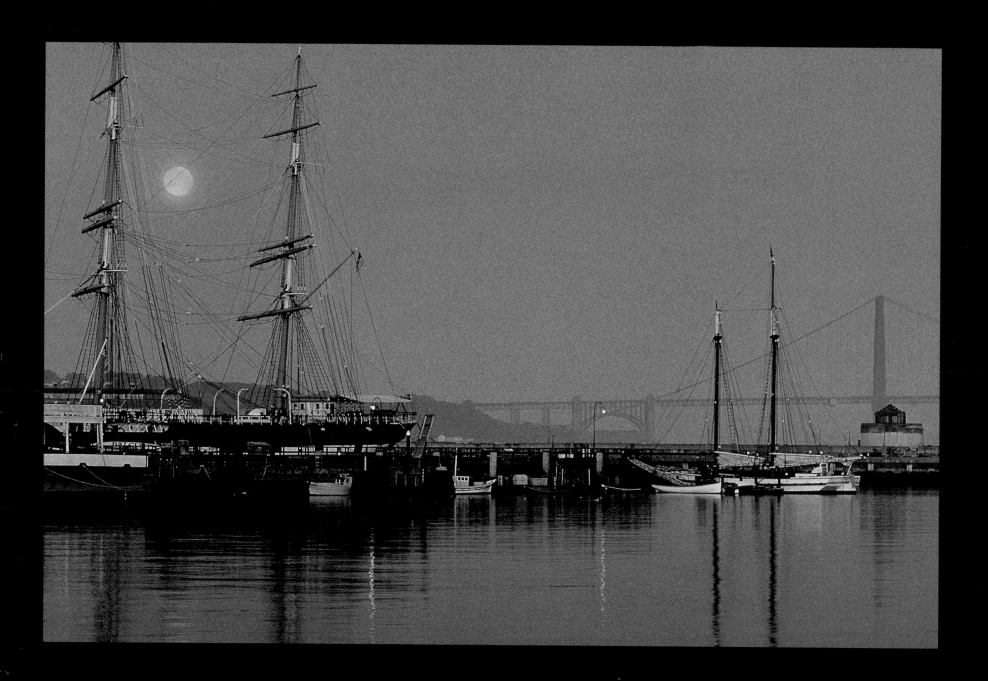

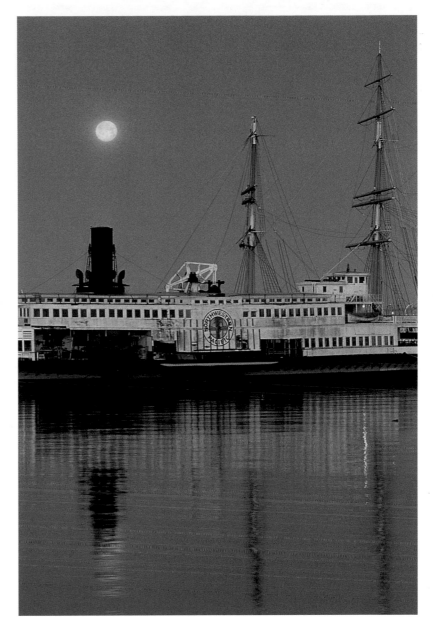

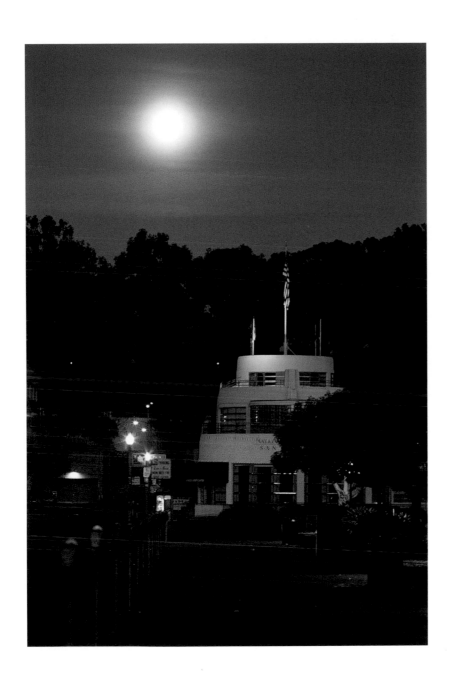

○ *Opposite:* March moonset over
wooden schooner C. A. Thayer; *Left:*
March moonset, Maritime Museum
from Hyde & Beach Streets; *Above:*
March moonset above the steam ferry
Eureka, Hyde Street Pier

○ *Above:* February moonset,
Fisherman's Grotto; *Right:*
January moonrise, Fisherman's
Wharf; *Opposite:* December
moonset, Golden Gate Bridge

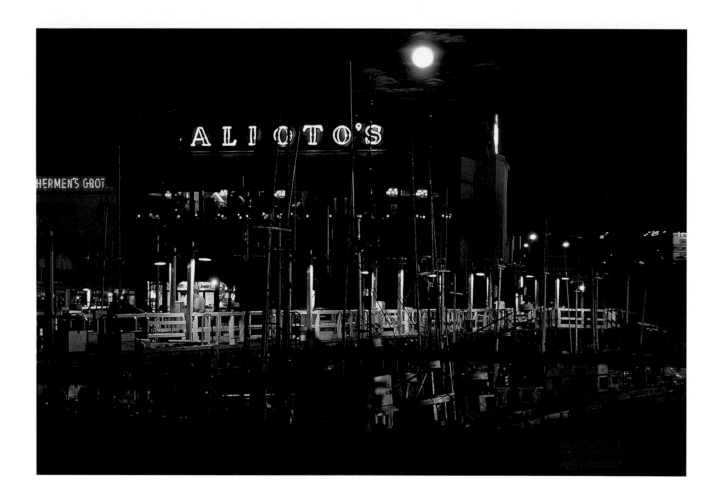

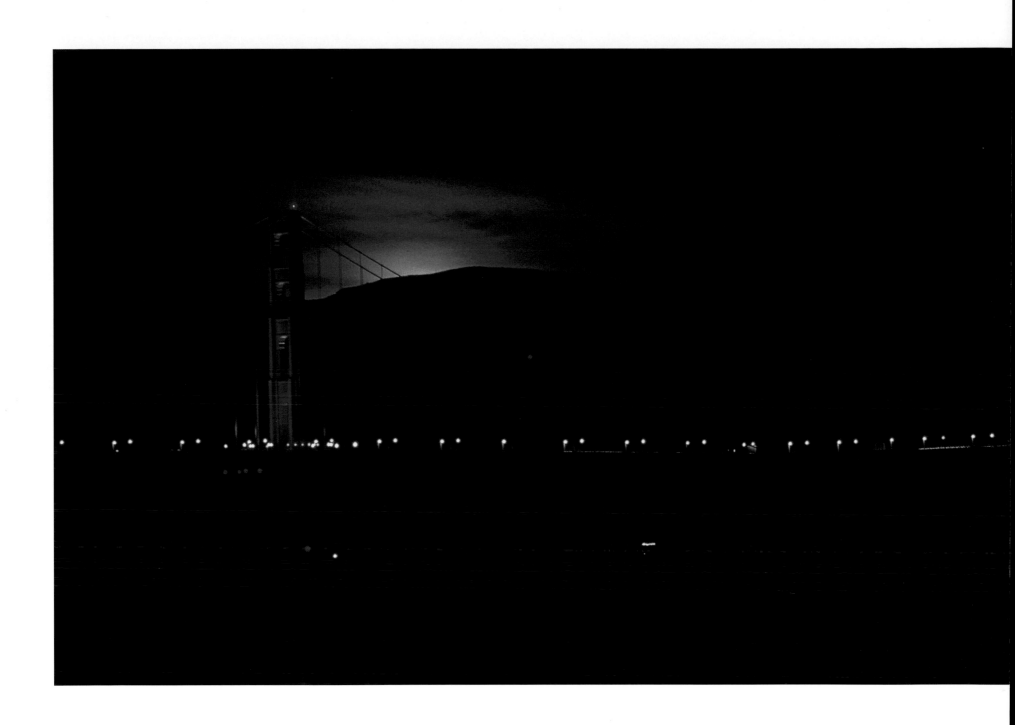

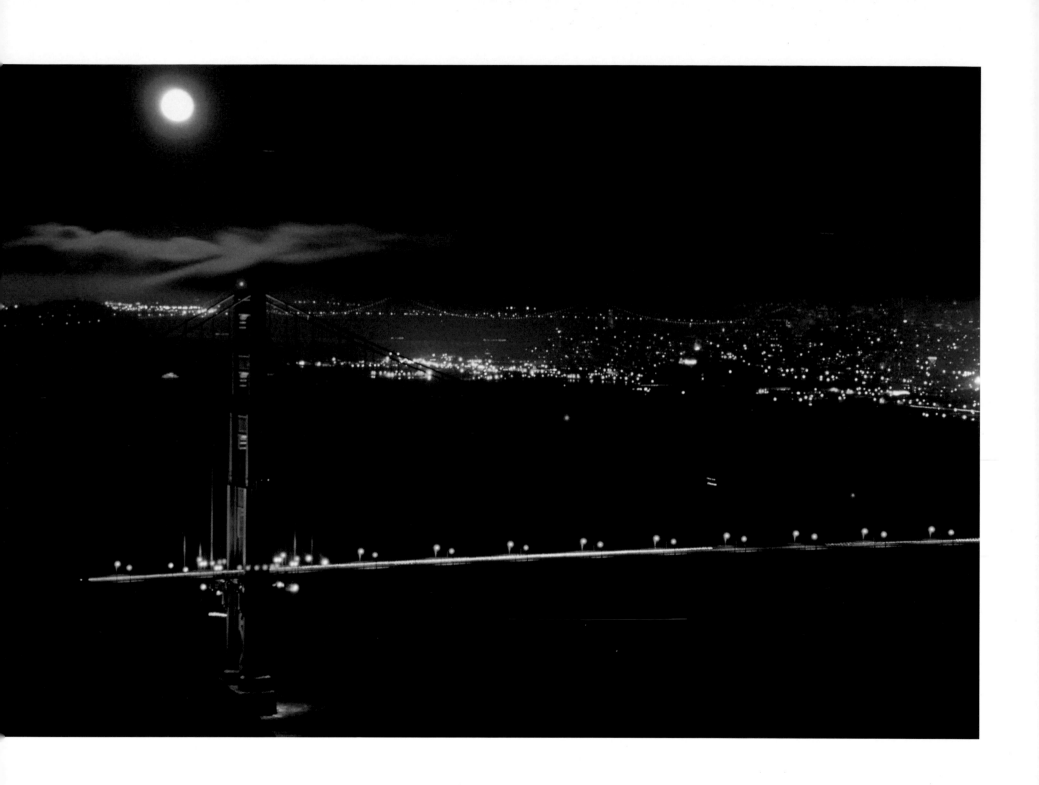

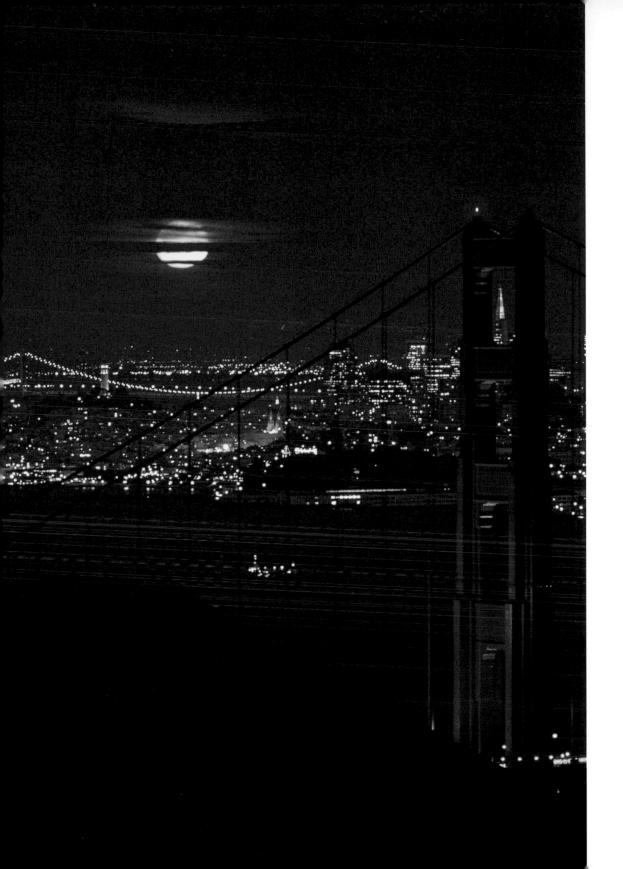

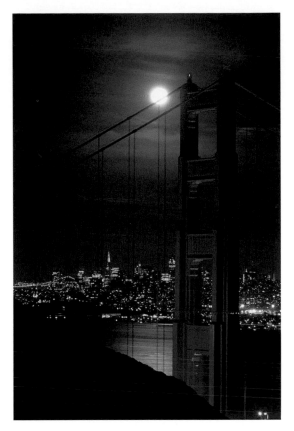

○ *Opposite:* August moonrise, Marin
headlands; *Left and above:* April moon-
rise, Marin headlands and Golden
Gate Bridge

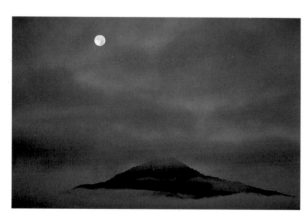

○ *Above:* September moonset, Mt. Tamalpais; *Right:* November moonset, Richmond/San Rafael Bridge

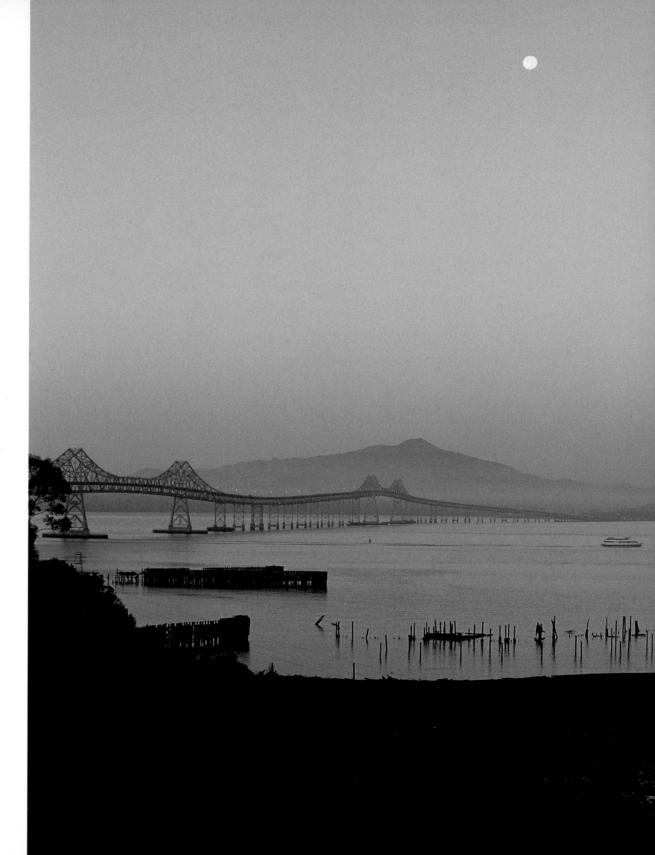

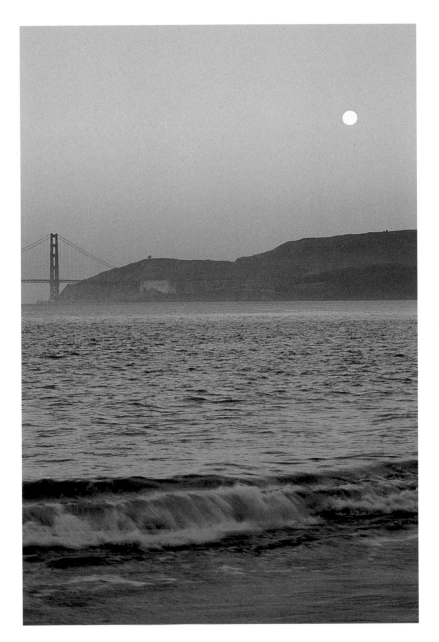

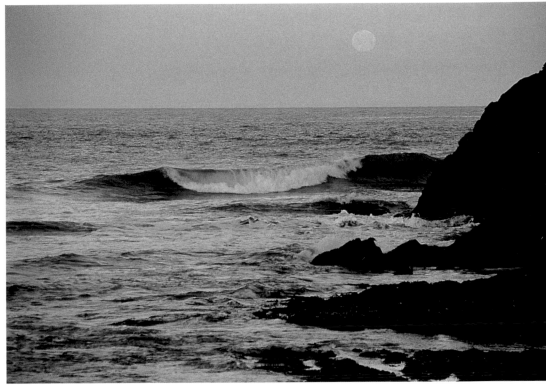

○ *Left:* July moonset from Angel Island; *Above:* May moonset, Cronkite Beach

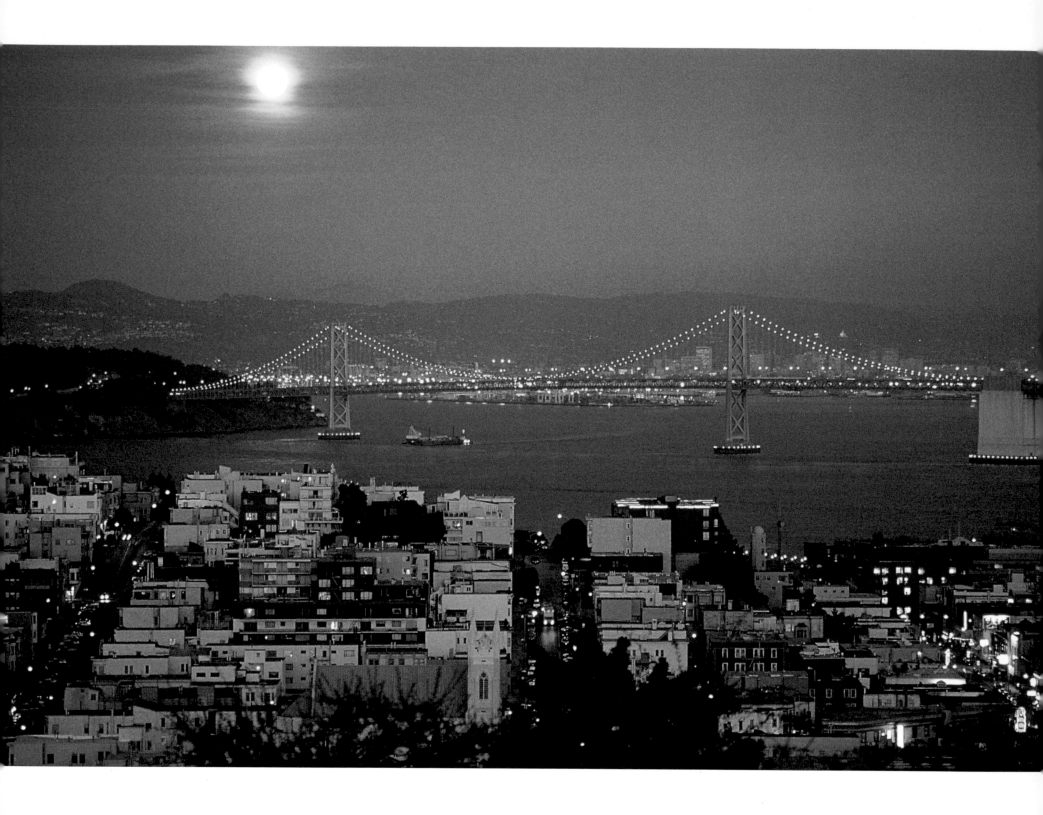

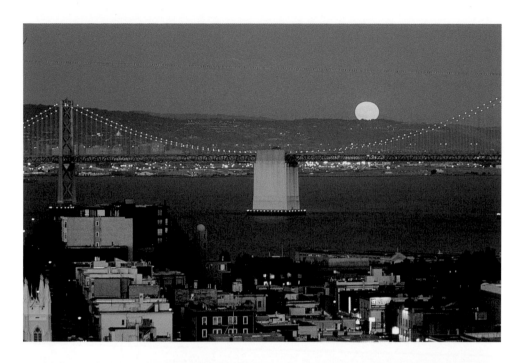

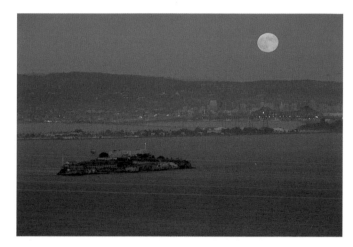

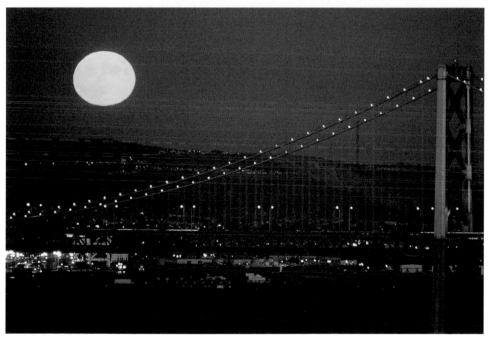

◯ *Opposite:* November moonrise from Russian Hill; *Left:* September moonrise, Bay Bridge (top); a few minutes later close up; *Above:* August moonrise and Alcatraz Island

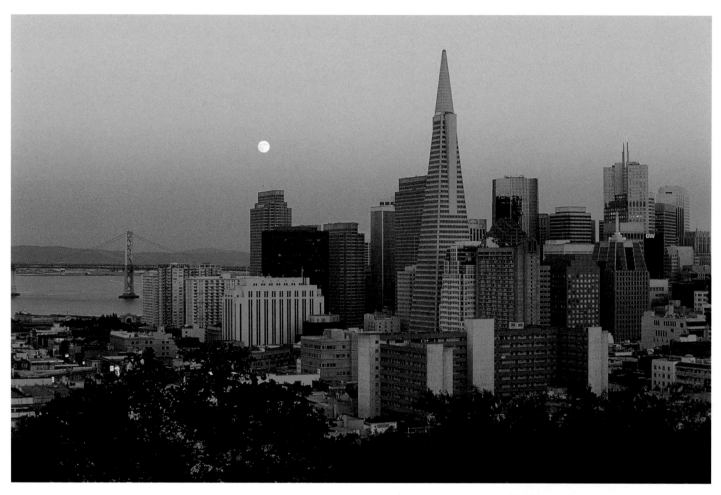

○ *Above:* September moonrise, financial
district; *Right:* November moonset, Jack
London Square; *Opposite:* April moonset,
Transamerica Tower; October moonrise,
Scott & Green Streets

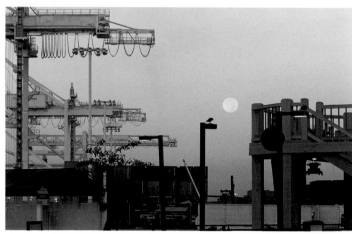

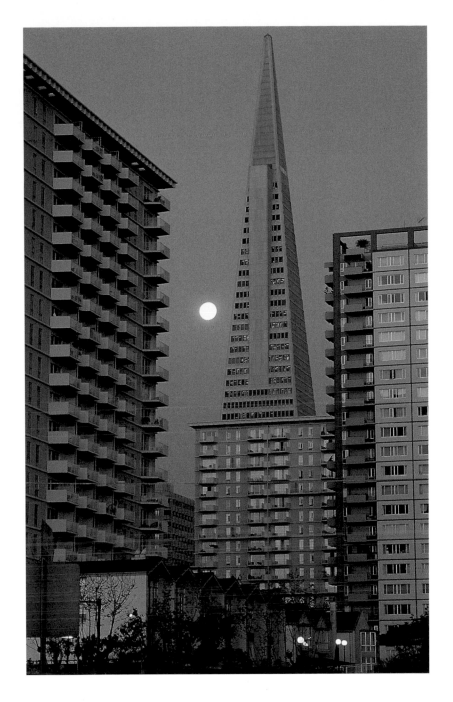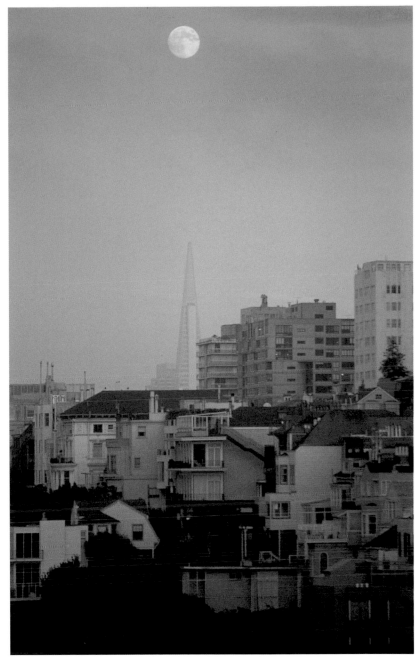

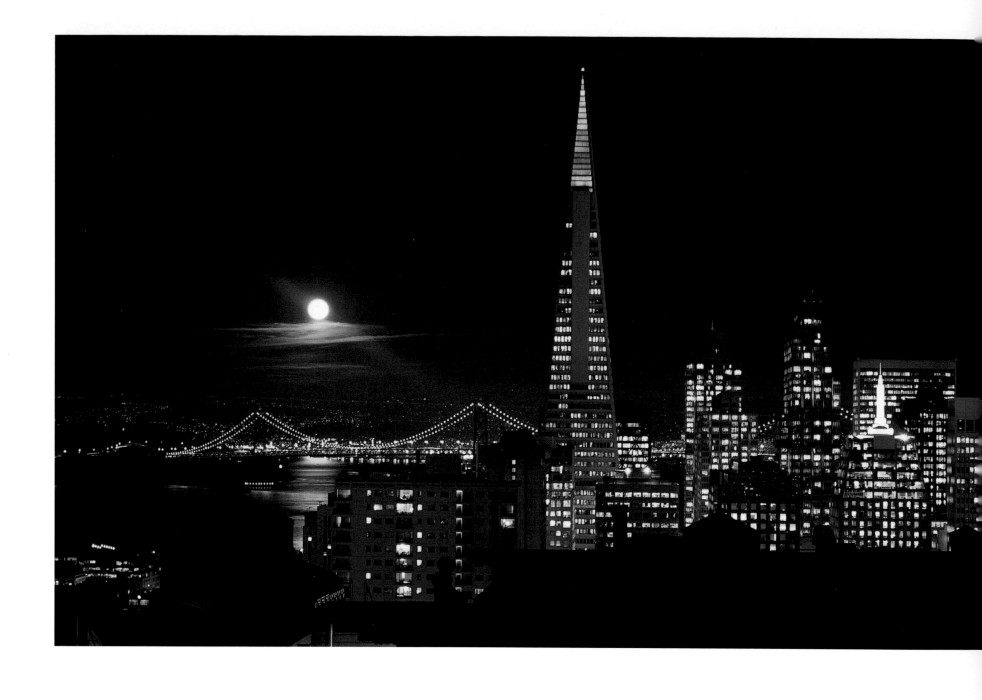

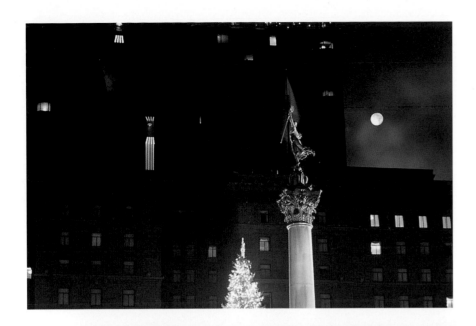

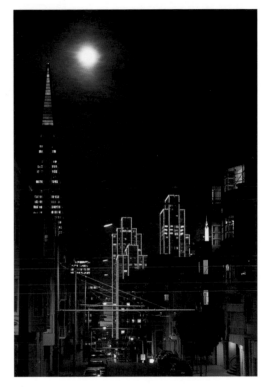

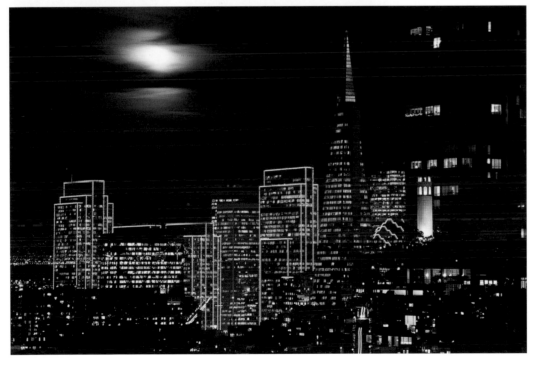

○ *Opposite:* November moonrise from Clay Street rooftop; *Left:* December moonset, Union Square (top); January moonrise, double exposure; *Above:* December moonrise from Clay & Jones Streets

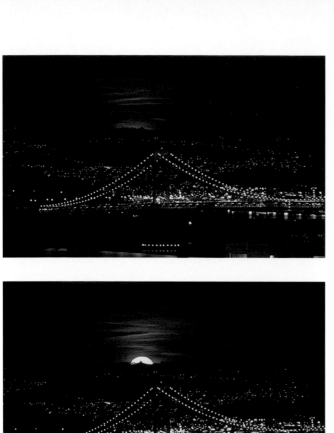

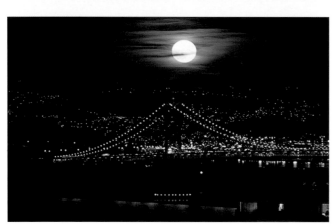

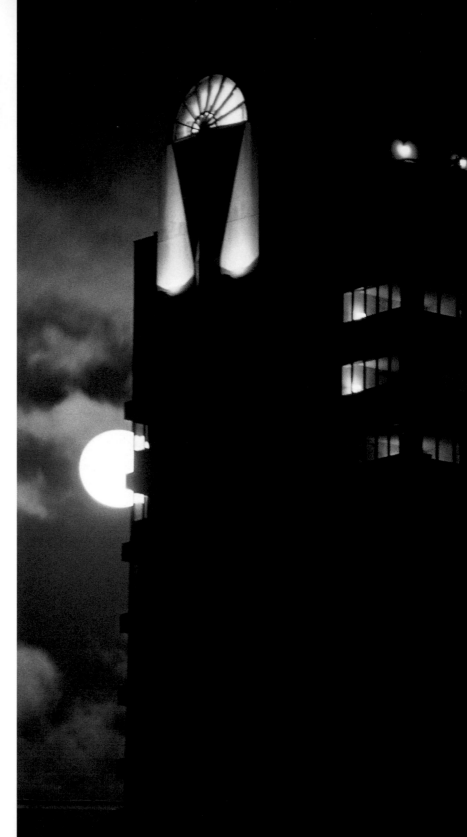

◯ November moonrise sequence, Bay
Bridge; *Right:* March moonset behind
the Marriott Hotel

Moon Glow Memories...

Sitting here in the Moon House on a damp and cloud-covered November morning with a fire hissing and popping and Chris Isaak—a good San Francisco guy—on the stereo. I hiked to the top of Ring Mountain to catch the sunrise and the best 360-degree view of the Bay Area: from Mt. Tam to the Golden Gate Bridge, San Francisco, the Bay Bridge, Oakland, the Richmond Bridge, and San Quentin. A great way to celebrate the completion of my quest for the many moons of San Francisco.

It has been an interesting sojourn that began just after the Loma Prieta earthquake in 1989. It must have moved me in ways I cannot consciously comprehend, but the aftershock has resulted in this book of full moons, a seven-year journey that has brought me full circle. I have explored the Bay Area with the pyramid as my anchor. No matter if it was night or day, I could always find that building in the skyline. It's good to know where you are on this planet and after shooting thousands of images of San Francisco in the moonlight, I feel that I am truly home.

Now that my perspective has matured, the journey complete, I thought it only appropriate to share a few of the moments that deeply affected me, images that are forever etched on my soul....

First Moon

My oldest friend on the planet, Curtis Roy "Not Boy" Maxwell, and his wife Linnea had come out from Phoenix to see us. We were all waiting for a table at the Sausalito Chart House in the old Valhalla building that the Grand Madam Sally Sanford put to such good use before her mayoral days. As we talked out on the deck, I couldn't believe my eyes. The moon was rising while the sun was setting and the glass buildings were reflecting the sun's last rays across the water to us. It was unbelievable. I ran to the car, grabbed the gear and shot a few rolls of film. Little did I know at the time that this would be the first of many moons that would mesmerize and enchant me, romantically linking me forever with the city of San Francisco.

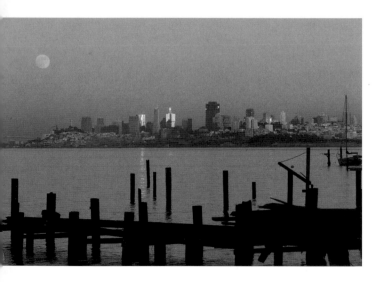

Top of California Street

The top of California Street just before sunrise on a full moon morning in March, my forty-first birthday. What a perfect present. I had been trying to crystallize this shot for over a year and had been close several times but never had all the elements line up. But on this morning magic was in the air. I raced the truck through the canyons of the financial district, pulled quickly to the curb, grabbed the sticks out of the back bed and ran up California, puffing hard. Just a few minutes before the sun broke the horizon, the moon slid perfectly into position and the cable car crested the hill, putting a true San Francisco touch to the moment.

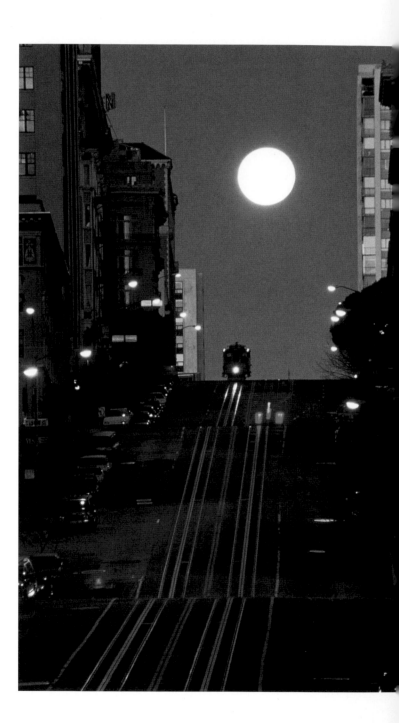

Double Exposure

I used to fear making mistakes, worried about not living up to my expectations. What I've learned through this moon chasing sojourn is that there are no mistakes, only interesting outcomes. This image is

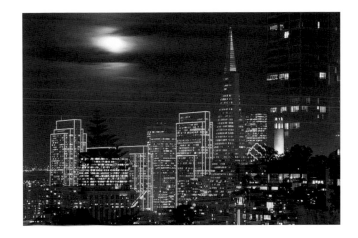

one of the double exposures that I shot unknowingly. I was taken completely by surprise when the slides came back from the lab. It was devastating to know that I had caused the mistake due to my own lack of attention to detail. But the longer I looked at these images, the more I began to truly like these guys. I was not going to include them in the book, but I have grown

to love them. These "mistakes," viewed from a different perspective, have become wonderful gifts.

Lunar Eclipse

Gail and I stood in the freezing September wind at the top of Lombard Street hoping the fog would break open for a few seconds so we could watch the total lunar eclipse and run a roll of film through the camera, maybe two. We had planned to watch the show from Mt. Tamalpais, but I wanted to get a photograph with a bit of San Francisco in the foreground. So there we waited at Lombard & Hyde, cable cars cresting Russian Hill behind us with that unmistakable churning sound. My mind debated the wisdom of the decision, frustrated that I'd have to wait forty years for the next one. I finally gave it up and began to enjoy the scenery. After all, this was San Francisco. And then it happened: the fog thinned long enough to shoot a few frames during totality. A reminder once again that the beauty of photography is that it makes you wait for the magic to unfold.

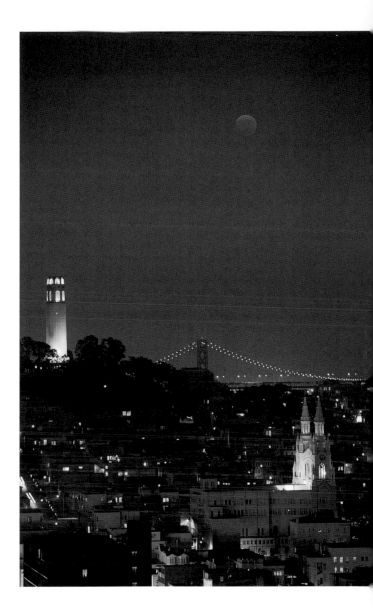

67

Bubble Gum Moon

We were set up overlooking Crissy Field with a clear shot to the skyline, waiting for the moon to rise. I had been envisioning this image for too many months and here it was unfolding in front of my eyes. The sun had just set behind us and the April moon was breaking the horizon a little to the left of the Transamerica building. We were positioned perfectly. The moon was bubble gum pink and the sky clear and twilight blue. The moon slipped behind the pyramid just as I had

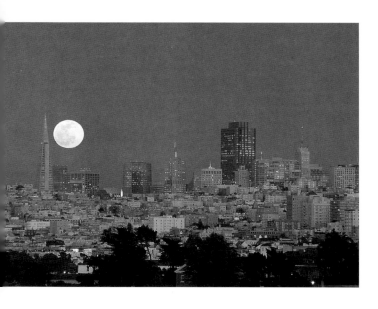

hoped and dreamed. I shot fifteen or sixteen frames, a good half a roll of film, when the camera jammed. I couldn't advance or rewind it. It was just stuck. I had the shot in the can, the one I had been planning for so long; the moon pierced by the pyramid, the olive on the martini stick. My mind raced through the options as the moon continued to climb with the light changing every second, colors mutating and the sky doing amazing things. I only had the one camera body with me. After several moments of considering the options, I decided to pull the half-exposed roll out and reload and continue on while this outrageous display of beauty and magic evolved. One of the toughest decisions I have had to make. It took about a minute to reload and in that short time the moon had moved up and to the right of the pyramid, my dream shot gone. I love this image, but it still hurts to think about what I had to give up to get this one. It's been several years now and I still go back to that spot, but the moon has never quite lined up like it did that night. But I keep watching, waiting....

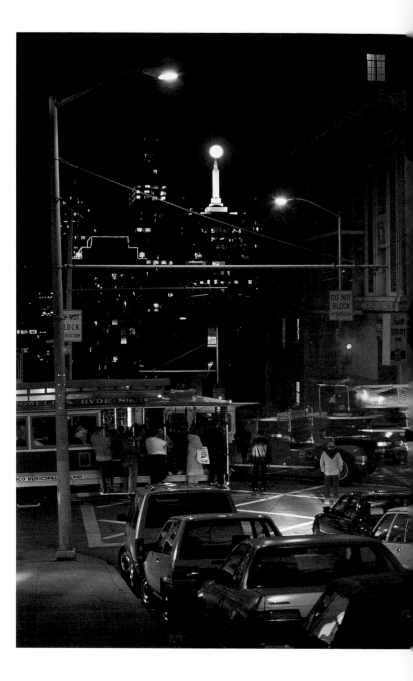

Chinatown

Crazy things happen on full-moon nights—there are more births, more deaths, more accidents, more crimes —weird things happen. The police, the bartenders, the doctors, they'll all tell you stories of the craziness on full moons. In fact, on this Saturday night in February on Chinese New Year, Gail and I were racing around chasing the moon through China-town, literally running up and down those hills with all the camera gear, a hell of a workout. We came to the intersection, Powell & Clay. The parade was happening a few blocks down, and here was this huge moon over what I call the "syringe" build-ing, 505 Montgomery, and it was lining up right above it. Gail was waving her arms, screaming "Rigler, Rigler look at this, get down here," trying to get me to hurry up. Well, there were four cable cars backed up. One had stopped right in the middle of this intersection, and rush-ing to a fire was one of those long fire trucks which had jackknifed there as well. So, you have the cable car, the fire truck, the cars and parade-goers trying to get through

the intersection. And here's this full moon pierced by the "syringe" building. Gail loves to point out the street sign on the corner that says "Don't Block the Intersection."

Frank's Boat

My mission was to shoot the moon setting behind San Francisco from Treasure Island. It had been a jour-ney of persistence and patience, testing my will and resolve and my ability to take what Mother Nature offered instead of trying to tame her. I had been all over Yerba Buena and Treasure Island for months trying to get the shot, above the Bay Bridge and below it, thwarted by fog and crazy drivers, by the time of the year when the moon was either too far north or too far south.

But then, at 4:30 in the dark of an August morning, friend Frank the Famous Framer and his Boston Whaler had me screaming through the Sausalito fog, out past Alcatraz and into the dry cold air of the East Bay. We slipped under the belly of the Bay Bridge in the cold blue-black darkness before sunrise. And there we floated motorless, waiting

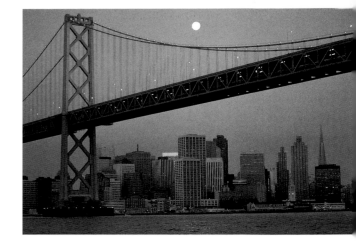

for the sun with the tide trying to flush us out through the Golden Gate and the full moon still high over The City, the lights of the bridge creating a pearl necklace draped around the pyramid. Frank had called the night before to tell me to bring an appropriate CD. So there we waited in the moonlight with San Francisco reflecting off the water and not another boat in sight, just the lighthouse on Alcatraz flashing through the fog every four or five seconds and Neil Young singing about the harvest moon, foghorns keeping time. It was one of those moments I will remember forever. I can even smell it right now. And we got the shot.

An Interview with James Rigler

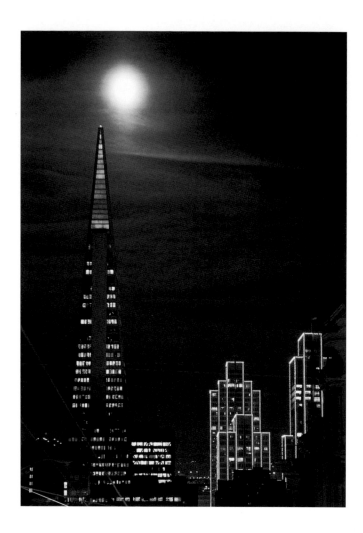

People who work alone, like artists, need other voices who can inspire, teach, and provide community. I have found these other voices by reading biographies and watching documentaries on artists: Picasso, Cezanne, Rodin, Gauguin, Monet, Van Gogh, Lautrec, O'Keeffe, Adams, Stieglitz, and others. They became my mentors and led me to several contemporary artists and writers who I have interviewed on tape to continue my search for inspiration. One of the first in this video series, *Conversations with Interesting Characters*, was Paul Chutkow, a writer best known for his biography on Gerard Depardieu, the wonderful French actor, and his interviews in *Cigar Aficionado* magazine and *The New York Times*. During the three years when I interviewed him, Paul became a friend. What follows is Chutkow's interview with me about my many-mooned quest of San Francisco.

Chutkow: All right, let's cut to the chase here.

Rigler: (laughing) Hit me.

C: Rigler, great piece of work.

R: Well, thanks, Chutkow.

C: I want to ask you in an unconventional way about some of the things that have gone into the book.

R: (nodding) Okay.

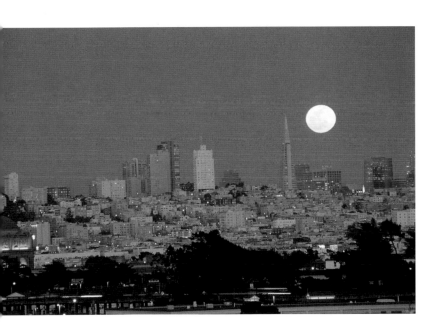

C: Passion?

R: Passion is something I've been searching for in my world for quite awhile. I felt I lost it for several years, and this project has brought it back. Chasing the full moon every month for the last six or seven years has created a wonderful rhythm in my life. It started out as an interest, then became a discipline, then an obsession, and now it is a lifestyle. A passionate lifestyle. I do believe it is important to allow your passions to gradually take over your conscious living, to truly live in the present. This project has been a lot of fun. It's great to be out in the world hunting for full moons in one of the coolest places on the planet. San Francisco inspires passion. It is a rugged and magical place to live, with the Pacific Ocean right there, the fog, the winter rains, earthquakes, fires, 2000-year-old redwoods, and roller coaster hills. I feel extremely fortunate to be allowed to be here. This place can spin you out quickly if it so chooses.

C: Rhythms?

R: Everything happens in, what is it, 28 to 30 day cycles. Men have it as well as women. Menstrual cycles, biorhythms, mood swings, lunar phases. This project has really made me aware of the rhythms in my world. It feels wonderful to have the project completed and out in the world, but this full moon chasing has become imprinted in my DNA.

C: Transformation?

R: Transformation, yes, in several different areas. Physically it's changed me. I am more in my body than I was before. I'm out racing around monthly looking for this thing. I'm up early and out late for three days every month. I get extremely exhausted doing it and I'm beat for several days. But, spiritually it's changed me. Whenever I see a full moon rising out of the horizon, it provides me the physical evidence that there is something greater and more powerful than just being alive and being human, that there is a greater power. I know for certain this greater power is one hell of an artist. I see that every month. It is the perfect proof for a visual person like me.

C: Mystique?

R: The moon is all about mystique. I'm always fascinated by how beautifully and quietly the full moon comes up over San Francisco. Always. It seems to happen without the usual constraints of time and space, like I'm floating in a dream, rendering my everyday concerns trivial and meaningless. There can be a lot going on: traffic on the Golden Gate Bridge, circling airplanes, crowds of people, whatever, but the world sounds muffled to me. Here is this huge ball rising silently and some people are aware of it, but most aren't.

C: Synchronicity?

R: Yes. I remember the first time I was set up with the camera pointed in the right direction and the thing came up exactly where I thought it would, the shot of the moon rising just to the right of St. Ignatius Church. The sky was black with storm clouds, but then a little break of about 45 seconds occurred just above the horizon, enabling me to run off a few frames before it disappeared back into the clouds. That's synchronicity. It's one of my favorite shots. However, most of the time, I'm chasing it, running after it, thinking it is going to be here and it shows up over there, five degrees to the right.

C: Light and color?

R: Light is everything in my world of film. Everything begins with light. Without light, there is no color. I've seen outrageous displays of color. The color of the moon changes constantly, from deep gold, to yellow, to pink, to red. In San Francisco you're dealing with every color imaginable. The setting sun reflecting off the glass windows of the buildings in the skyline, shining across the water like golden mirrors. And then that huge moon rising above the Berkeley and Oakland hills. Unbelievable. There was one I shot from in front of the Chart House in Sausalito. It was about ten o'clock at night in July, the night before Sean Connery and Nicolas Cage were holding the private screening of the movie "The Rock" on Alcatraz. At about ten, ten thirty it comes up blood red, right above Alcatraz. I've never seen it like that before or after. A few minutes later, the moon turned from red to yellow as it rose higher in the sky. The lighthouse on Alcatraz was throwing out a white beam across the water and the moon was casting a long red beam just to the left of the lighthouse beam. It was beautiful. I've been very fortunate to be right place/right time, film in the camera and the lens cap off. (laughing) How about that for awareness?

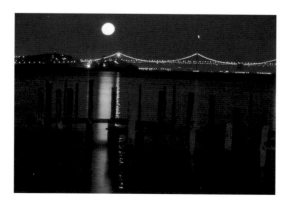

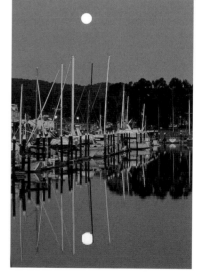

🌙 C: Methodology?

🌙 R: Yeah, there has been some method to my madness. When I look back over the six years of doing this, there's definitely been a method to it. It started out as a connect the dots picture, chasing one thing after another, not sure what we were creating. After so many months I realized that, heh, we've got something here. This is becoming an interesting body of work. In the last two or three years, it has been a quest to photograph the moon from the different angles around the Bay Area that I hadn't yet captured. So, there has been a method of looking at the map and trying to predict just where and when the moon will set, where it will rise.

🌙 C: A day's routine?

🌙 R: During the chasing, I'll usually start a night before the full moon. The actual full moon is only a second in time and usually does not happen at sunrise or sunset. So, I'll be out the night before to capture the moon rising while the sun is setting. The light's usually great. It varies throughout the year, but normally I can count on the night before the actual full moon to be a great time to shoot. I'll catch those beautiful pastel colors of sunset and have a nearly perfect full moon. The night of the full moon will more often be a lot darker. The sun has normally just set, particularly in the winter months. It's fascinating to know when to shoot this thing and where to look for it, and when to get the perfect light, because this moon really travels throughout the year. I can sit out on the headlands above the Golden Gate Bridge every month of the year and it will come up in a different

place each time. This last October moon, from my spot in the headlands, it came up right behind Mt. Diablo. In June, it came up behind Coit Tower. I don't know how many degrees difference that is from Mt. Diablo to Coit Tower, but

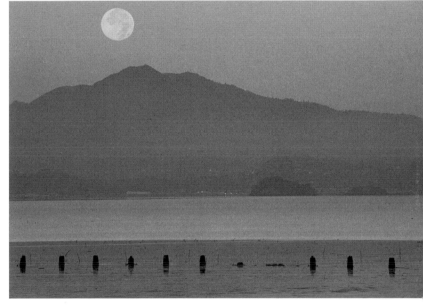

it's a huge distance to travel. So, usually I'll start the night before the full moon. I'll shoot for an hour or two past sunset. Once it gets an hour above the horizon, it's too bright, it's too white to shoot at that point. It just burns everything out. Then up at about four in the morning to catch the moonset just

before the sun rises. Gail will join me a lot of the time—she likes riding shotgun. And she's a good spotter, too. So, my routine for several months was to get up early at four, get in the truck and drive across the Richmond Bridge and get to Oakland or Pt. Richmond or Berkeley or the Oakland hills. I shot some great images from Treasure Island, catching the moon setting behind The City. So it's been a circular thing from here in Mill Valley to the Oakland hills and then back over the Bay Bridge, chasing it through The City, ending up over by the Palace of Fine Arts or Aquatic Park, running with the gear to catch

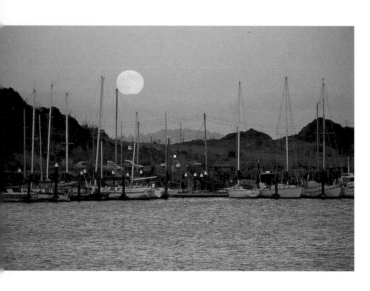

the last of the set, before it goes under. Then, back across the Golden Gate Bridge and home about an hour after sunrise. It goes like that for three days.

C: A celestial chase?

R: (laughing) Exactly, and it's great that the publisher is Celestial Arts/Ten Speed Press out of Berkeley. A little synchronicity there. These guys fell in love with it from the very first time they looked at the mock-up that Gail designed. They view the world through similar eyes.

C: Community?

R: Oh, very much so and growing. Once you start talking full moons, everybody has a wonderful experience to relate. They remember doing something special, something romantic or unusual under the soft glow of the moon. There is a common bond, a shared experience. Everyone is affected by the moon. Everyone. Some have commented that since they looked at these images, they have become more aware of the moon, where it rises and where it sets, and what happens in their world during that time. It is a great conversation starter.

C: Romance?

R: Definitely. This city is a romantic place. Every direction you look, every song you hear sung about it. In fact, I just saw where Tony Bennett is coming to town again for a big show. People really do leave their hearts in San Francisco. How much more romantic can you get than being in San Francisco during a full moon, looking at the Golden Gate Bridge, Coit Tower, cable cars, and the Transamerica pyramid? What a beautiful skyline.

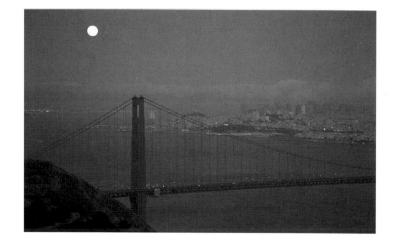

C: Architecture?

R: It's very unique here. This is an artistic place. The music, the art, the theater, the things that are happening here are just unbelievable. And it's reflected in the architecture. Every bridge is beautiful, every building unique. Every time I drive across that Golden Gate Bridge, I'm in heaven. It is the coolest looking bridge, and they light it so beautifully at night. From every angle it is magical. San Franciscans are a proud lot and they passionately protect the look and feel of their city.

C: Equipment?

R: Very important. I used to be totally a Nikon guy for fifteen or twenty years until I had an experience several years ago that really affected me on many levels. I went to a seminar put on by a couple of

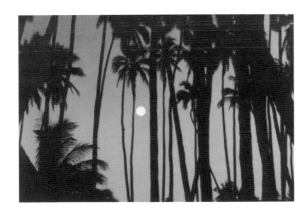

National Geographic photographers, Rikki Cooke and Dewitt Jones. They're great friends who put on a seminar twice a year for photographers on the island of Molokai. It was one of the best experiences I've had. A week of hanging out on Molokai with men and women from all over the world who express themselves through photography. We talked equipment, art, poetry, we talked anything and everything, just the creative spirit running freely. Most of them had recently switched to Canon equipment. These were all top of the hill, world renowned photographers and they had all gone to Canon cameras and lenses. Rikki Cooke and I spent some time together after the seminar. He opened his bag of equipment and talked about his gear with me. It was great. Just the two of us talking cameras, sitting on the deck of the home he had built with his own hands. He recommended that I go with this new equipment and that it would free me up artistically. Well, a few months later I made the switch and he was right. The metering system is unbelievable. The design is well thought out, the glass is quick, light, and sharp.

C: Creation?

R: Interesting process. After years and years of shooting this moon, I now have created something unique and special, a book of moons. And it will now have a life of its own. I've created something from nothing, which feels great. Full circle. (laughs)... You know, when you look at the full moon, you're looking at one of the strongest geometric shapes in the universe. The planets are circles, the moon and the sun are circles, your life is a circle, birth-life-death-rebirth, everything is a circle. I see circles everywhere I look these days. This full moon thing has really put its spell on me. Yeah, I'm fascinated by it... I'm a moonatic, Chutkow. (laughs). How 'bout it. (laughs)... I've been touched by the moon.

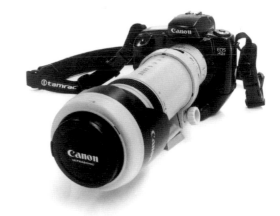

C: Creative synergy?

R: What I have found from this project is that nobody does it alone. I would like to say I did it totally myself, you know, the ego part of me would like to say that. Yeah, I took the photographs. I was there, I did it, I went out and persistently pursued these images. But I have had help. I have had good people who really believed in the project, and more importantly, believed in me. First of all, it's been Gaily. Gail Ward. She's believed in it at times when even I didn't. She was right there whenever I was low, discouraged, disgruntled, or depressed. She designed the mock-up. She helped schlep the gear, always carried more than her share. Gail is one of those people who has the unique ability to grow things, to help bring dreams to life—a mystical midwife. She's been a wonderful person and partner in my world. I

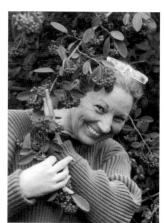

○ Gail Ward.

love you, Gaily. And you, Chutkow, have believed in this thing from the first time you saw it. From day one you've been right there. You've been like a big brother to me, as well as an example of how an artist lives. It's been great to see how someone else does it, and does it on a world class level. Robert Stricker, Motherstricker, my crazy and talented agent who brought a calming influence to the table. He likes to run in the moonlight out on the bike path, a kindred spirit. My publisher, David Hinds, and my editing poohbah, Heather Garnos—they both have been great to work with. Hinds loves the San Francisco Giants, so we talk a little baseball and sports in general. Brad Greene, the designer, is on our same wavelength and loves Wendy, motorcycles, pussycats, photography, and moons—a great guy to work with. Hinds, Brad, and Heather truly understood what Gail and I were

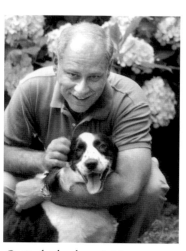

○ Paul Chutkow & Maggie.

striving for with this project. Alex Ivanov, the Marin maestro of B/W film and fisherman extraordinaire. The talented gang at The Light Room, my friends at Photo Sprint, Seawood Photo, The Film Company, Just Film, and The Darkroom. Michael Kloepfer helped keep me organized and detailed, and Helen always makes us laugh. Peter Robinson, the literary king and teller of bad jokes. Chris Felver & Marilla—always there to give an opinion and a show of support. My sister, Sally and my folks, Jack and June, who believed in me regardless of how crazy it looked. Frank the Famous Framer & Kim, Maynard and the Idiot Savant. Bruce & Norma, Edye & her gang. Kathy Mac and her Mac Moon Parties, TR, JW, Benjamin, Valerie, Ben & Laurie, Dr. Paul, and Allyson who would always call to see how things were going. Kent & Patti Anderson, Dan Burke, Greg Norris, Bob Greene, Helen Ford, Catherine Cotchett and the Moon House. The feisty neighbors, Rusty, Susan, and Ellie. The Crazy Priest,

China, the OLMC gang, Von, Eddiemon, and many friends from around the globe: Gibbons, Cox, Jillian, Jonathan, Jackie, Crazy Lady, Montana Mo, Levow, Maxie Boy & Linnea, Kerry, Lyle & Kristen, Fred, and the three pussycats. And last but not least, Liana "The Kid" Lasko and David, who have put up with all the early mornings and late evenings and endless hours of moon talk. All of these people have been a big part of this project, and they've all put a certain amount of their energy into it. I know it's become a better thing because of their input. These people and many others have been the creative synergy in my life, kindred spirits who love San Francisco and who are all romantics at heart. I'm honored to have them as friends and family.

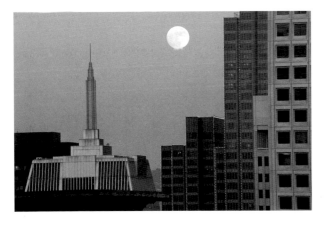

C: Divine inspiration?

R: Maybe so. When I look back at my life I'm beginning to see a pattern emerging. From a little kid hanging out with my old man in Wyoming and Montana to the big kid I am today. My dad grew up in Great Falls, Montana, so we were always back there, just the two of us, camping in the mountains, always looking at the night sky. His favorite things were the constellation Orion and the moon. So, from an early age, I've been attracted to this moon, to the night sky, to things that were happening all the time silently if you were just aware of it. My mother would always be seeing pictures in the clouds or sketching in her art books, keeping my sister and me interested in the world around us. So maybe I was destined to do, or at least inspired to do, what I am now doing, capturing images on film. I've always wanted something that would allow me to move freely, to have no geographical boundaries, no constraints of time and space. Photography does that. I feel very fortunate to be in a position to realize a few of the dreams that have been swimming around in my mind all these years.

I find it amazing how things magically happen when you focus your attention and awareness. Photography has taught me the technique of focus, my dad taught me the art of persistence, and maybe that higher power inspired it all. However it all came together, I'm very grateful. I truly love what I do.

C: Congratulations. (shakes Rigler's hand)

R: Thank you, Chutkow. I really appreciate it.

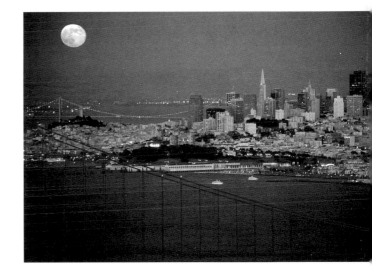

The Photographer

James Rigler is an incurable romantic who has been forever affected by the beauty of San Francisco and the pull of the moon. He was born in Chicago and raised along the Mississippi River in the beautiful rolling hill country of Iowa. After graduating from Colorado State with a degree in finance and real estate, he engaged in various financial and advertising ventures in different parts of the country before eventually spinning off into the visual world of photography and film. He created his own production company in Taos, New Mexico, and moved it to Northern California just in time for the Loma Prieta earthquake of 1989. The Bay Area has moved him ever since.

Rigler is nationally known for his photographic series, *The Natural State of Being,* a study of the human body in the natural environment, and for his black and white sculpture series photographed while traveling the country in a motor home for two years. He continues to shoot the moon in and around San Francisco, a discipline that has become a passion. Along with *San Francisco Moon,* he is currently producing the videotape series, *Conversations with Interesting Characters,* which profiles the lives of artistic people who are doing what they love and making a positive difference in the world. He lives in Marin County and has his headquarters in a studio in the old shipbuilding section of Sausalito.

While shooting this book, I was literally running with the gear from shot to shot, chasing moments in time. Having the right gear is essential and over the years I have honed my equipment down to a very manageable amount. My criteria are simple—it must be top-of-the-line quality, durable, light, efficient, and it must all fit into two small bags. My cameras and lenses are Canon, the tripod is by Bogen with a quick release head, the bags are made by Tamrac, and the film used to shoot this book of moons was Kodachrome 200. I have never used a vest until this project and I must admit that I have grown very fond of all the pockets on this Domke rig.

○ Clockwise:
Camera body: EOS A2E
Lens: EF 35-350 L 3:5-5.6
Lens hood: EW-78
Remote switch: 60T3
Teleconverter: EF 1.4x
Vertical grip: VG10

○ Clockwise:
Camera body: EOS A2E
Quick release attachment for tripod
Lens: EF 20-35 3:5-4.5
Lens: EF 75-300 1:4-5.6
Remote switch: 60T3

CELESTIALARTS

P.O. Box 7123
Berkeley, California 94707

Distributed in Canada by Publishers Group West, in the
United Kingdom and Europe by Airlift Books, in New
Zealand by Tandem Press, in Australia by Simon & Schuster
Australia, in Singapore and Malaysia by Berkeley Books,
and in South Africa by Real Books.

Cover and interior design by Brad Greene
Photographs of equipment by Alex Ivanov
Photographs of James Rigler by Gail Ward

Library of Congress Catalog Card Number: 97-078336

First printing, 1998
Printed in Hong Kong

1 2 3 4 5 6 - 03 02 01 00 99 98

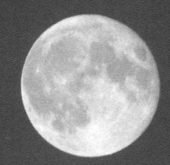